DOOR COUNTY

— T A L E S —

DOOR COUNTY

T A L E S

Shipwrecks, Cherries and Goats on the Roof

GAYLE SOUCEK

Charleston · London

THE
History
PRESS

Published by The History Press
Charleston, SC 29403
www.historypress.net

Copyright © 2011 by Gayle Soucek
All rights reserved

First published 2011

Manufactured in the United States

ISBN 978.1.60949.234.2

Library of Congress Cataloging-in-Publication Data

Soucek, Gayle.
Door County tales : shipwrecks, cherries, and goats on the roof / Gayle Soucek.
p. cm.
ISBN 978-1-60949-234-2
1. Door County (Wis.)--History. 2. Door County (Wis.)--History--Anecdotes. 3. Door
County (Wis.)--History, Local. 4. Door County (Wis.)--Biography. I. Title.
F587.D7S68 2011
977.5'63--dc23
2011017165

Notice: The information in this book is true and complete to the best of our knowledge. It is offered without guarantee on the part of the author or The History Press. The author and The History Press disclaim all liability in connection with the use of this book.

CONTENTS

FOREWORD

Almost every visitor to Door County drives either through Peninsula State Park or at least past it on Highway 42. As you pass the entrance, south of Ephraim, and gaze back to the west, you notice a huge totem pole located on the golf course. The early Indians who settled Door County did not have totem poles, but they are common in the northwestern United States, especially Alaska, as well as portions of Canada.

This particular totem pole resides on the site of the largest funeral in the history of Wisconsin, that being the funeral for Chief Simon Kahquedas, of the Potawatomi Indians. I recently watched a documentary on Wisconsin Public Television visiting old cemeteries in Wisconsin (Peninsula Park being home to three burial areas). The documentary noted that the totem marks the chief's grave, when actually a limestone boulder marks the burial site proper. The totem, according to Door County historian and author Hjalmar Holand, is a monument to the former owners of the land, not an elaborate headstone.

Everyone who settles in Door County has a story to tell, from the early Scandinavians to the modern tourists. My family's story began in the 1930s, when my mother's uncle, "Uncle Nord," left his home in Wilmette, Illinois, to visit Ephraim and to fish for bass. He always said that Ephraim had the best bass fishing in Wisconsin. So began a love affair with the county that spans almost eighty years.

Back in the early 1980s, when my wife, Connie, and I relocated to Door County as full-time residents, a local author had penned a play entitled *Portes des Mortes* (or *Death's Door*). We've all heard the legend on the naming of the water passage between the mainland and Washington Island. Two warring Indian tribes were responsible for the "Death's Door" name after

one tribe lured the second tribe's warriors into a trap by lighting signal fires on the rocky bluff overlooking the stormy waters. The attacking canoes were dashed on the limestone cliffs, and the survivors were killed or captured.

The play depicted early settlers and their trials and tribulations (and humor) as these early transplants turned this wilderness peninsula into a farming, hunting and fishing economy and, eventually, a tourist delight. Another appeal of the play was the use of relatives of the early pioneers in the roles of their ancestors. Though by then we had only lived here for a short time, we knew many of the participants in the play and greatly enjoyed learning about a small microcosm of their family history.

In the late 1980s, I was involved in the fishing industry, working with David Peterson, a young entrepreneur, who supplied whitefish and chubs to many of the Chicago and Milwaukee fish outlets. We were purveyors, bringing Door County products south, as well as specialty foods and other food products back to the Door. As fate would have it, one day in an Egg Harbor distilled beverage distribution center (bar), I met a gentleman named Bob Anderson. Bob did my job back in the 1950s and 1960s. The travel was a little more difficult for him, the trucks lacking a lot in power, and Bob could not make it up some of the bigger hills. He had farmers with tractors meet him at the base of the Sister Bay hill and the Kewaunee hill to tow him to the top. After Kewaunee, it was clear sailing. I guess I had it pretty easy.

Years ago, I met Ben Wilting, who as a young boy over on Whitefish Bay met the fishing boats early in the morning upon their return from emptying their nets. Ben helped to unload, clean and ice the fish, haul the iced boxes down to Sturgeon Bay and load them on the train bound for the restaurants and fish houses in Milwaukee and Chicago. The fresh fish on the tables in the city were caught the same day they graced the restaurants' plates. This was back in the 1940s.

The fish tugs came up the creek at Whitefish Bay, unloading at the mammoth log piers extending out into the Lake Michigan waters. The fish houses on the creek became famous, being the subject of numerous paintings and photographs of the creek, shacks (often depicted in later years in disrepair) and the huge pier. Today there is nothing left but a few pilings and wonderful memories of days gone by.

And so it is with every Door County tale. All who venture here have a story to tell and an eager audience to listen.

Bob Erickson
Fish Creek, Wisconsin
March 2011

Introduction

I know that you believe you understand what you think I said, but I'm not sure you realize that what you heard is not what I meant.
—Robert McCloskey, American author and illustrator

I love Door County. When others speak of quaint European cafés or endless white sand beaches, of decadent cruises to colorful islands or of dancing until dawn in a trendy nightclub, my mind wanders north to the little peninsula jutting out into the deep blue waters of Lake Michigan. I've traveled quite a bit in my life, but no other place has yet stirred my soul in quite the same manner as the picturesque and eccentric villages on Wisconsin's "thumb." For many years, my husband and I have walked its shores, breathed the fresh lake air and spent considerable sums of cash in its fine restaurants and charming shops. When the opportunity came along to write this book, I jumped at the chance to wax euphoric about my personal little slice of paradise.

That is, until I began the research. Do you know how many ways there are to spell "Potawatomi"? I discovered that the options are nearly endless and that few resources—including official state sites—seem to spell the tribe's name the same way twice—even within single documents. It's the same thing with the names of settlers. Was it Andrew Roeser or Andre? Or perhaps Roesser? Did you know that the same shipwreck can be found in two entirely unrelated spots on different ends of Washington Island? Old records are sometimes incomplete or downright incorrect, and each casual historian throughout the years has put pen to paper with his or her own personal interpretation. For months I agonized over each little detail, afraid

that I would somehow dishonor the place I loved so well by missing a key point or twisting a fact.

Finally, it dawned on me: the whole point of Door County, its entire raison d'être, lies in its ability to calm the body and clear the mind. An advertising slogan once referred to its location as "north of the tension line." With that in mind, I returned to my original purpose when I began this book: to explain, to the best of my ability, how Door County came to be and to give the reader a glimpse into the quirks and oddities that define the towns and their unique culture. I hope you'll forgive any errors that might have escaped my scrutiny. Most of all, I hope you'll come up to Door County to visit; you won't be disappointed. And if they ever agree to a standard spelling for Potawatomi, I'll be sure to let you know.

Part I

By Land and Water

THE QUEST FOR LAND

Discovering this idyllic place, we find ourselves filled with a yearning to linger here, where time stands still and beauty overwhelms.
—author unknown

In this day of our homogenized consumer culture, northern Door County stands as an anomaly. Here there are no golden arches, talking Chihuahuas or stores with names ending in "mart." There are no theme parks filled with larger-than-life costumed characters and no obligatory tourist traps that leave your wallet—and your spirit—largely depleted. A weary traveler won't need to glance at the hotel stationery to help his sleep-fogged brain recall whether he's in Pittsburgh or Houston or Modesto or Chicago, where the endless business districts all blur into the same cacophony of corporate logos. In fact, once a visitor passes north of Sturgeon Bay, not a single stoplight impedes the journey as the roads wind through an assortment of delightful small towns, each proudly bearing the marks of its frontier birth.

Actually, the Door Peninsula is rare not only in its present-day lifestyle but also in its geological formation. It is a twin to the mighty Niagara Falls to the east and forms part of the rim of a giant basin that cradles three of the Great Lakes: Michigan, Huron and Erie. Scientists tell us that more than 420 million years ago, during the Silurian age, a vast tropical inland sea covered the area from New York State up into Ontario and through Michigan and the eastern edge of Wisconsin. Sediment from the sea, including the calcified shells of its residents, built up a limestone layer that gradually formed a capstone of harder dolomitic limestone (dolostone) as magnesium crept into the mix. Over time, the center of the basin began

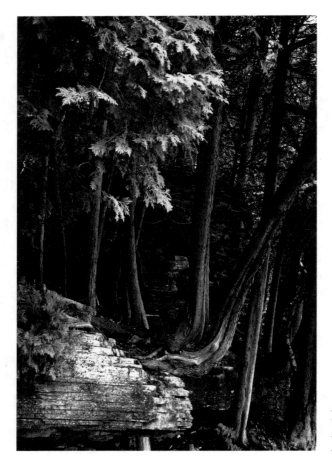

Ancient cedar trees cling to the limestone bluffs along Green Bay. *Photo by Peter Rimsa.*

to sag from the weight of the sediment, forcing the dolomitic rim upward. Once the sea started to recede, this erosion-resistant capstone remained as the softer limestone washed away, leaving the towering bluffs of stone that characterize what is now called the Niagara escarpment. This escarpment (also referred to as a "cuesta") begins on the east at a point near Watertown, New York, and arches in a horseshoe shape up into Ontario and along the shores of the Georgian Bay, through Michigan's Upper Peninsula and down along the western shores of Lake Michigan, where it forms the backbone of the Door Peninsula. It finally slopes to a humble end north of Chicago near the Wisconsin-Illinois border.

The Door Peninsula got its name from the dangerous straits that pass between the tip of the peninsula and Washington Island, which sits seven

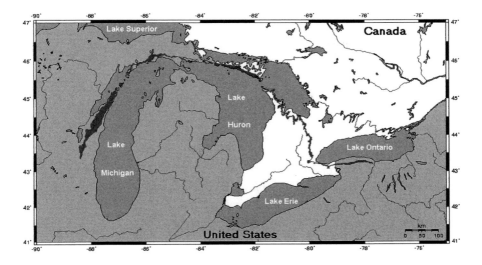

The Niagara escarpment forms a rough half-circle from New York on the east up into Canada, across Michigan's Upper Peninsula and down through the Door Peninsula.

miles to the northeast. Here the waters of Green Bay meet the waters of Lake Michigan in a dangerous and unpredictable confluence of currents. Early explorers and merchant ships, as well as local Indians in canoes, all too often met an untimely death in the capricious waves. The passageway is littered with the remnants of vessels that foundered in the sudden high seas or were dashed to bits against the rocky shoals. One legend tells of a dramatic battle between warring factions of the Winnebagos on the mainland and Potawatomi Indians on Washington Island. There are several versions of the story, but each version agrees that as many as six hundred young braves perished in a sudden storm that rose up in the passage and drowned them in their canoes. Although history is vague on what really transpired, the French explorers had enough fear and respect for the waterway that they named it "Porte des Mortes," literally the "Door of the Dead" or "Death's Door." Some historians claim that the area has the most shipwrecks of any body of fresh water in the world.

Due to its dramatic birth from water and stone, even today the peninsula displays a rugged toughness as waves crash against its rocky shorelines and ancient cedar trees cling precipitously to the vertical cliffs. Researchers have determined that some of these trees are more than 600 years old, and they suspect that even older ones exist, but they are too inaccessible to safely sample. It's likely that some cedars on Eagle Bluff in Peninsula State Park,

and some on Rock Island, might be as old as 1,200 years or more. These trees offer a glimpse of the old-growth forests that once thickly covered the land long before the arrival of man. Although the average depth of topsoil in northern Door is only about 3 feet—and in some areas, only a mere few inches of soil covers the hard bedrock below—the climate still provided the perfect environment for an almost unbroken expanse of hardwood and conifer forests—that is, until the first white settlers came, greedily coveting the treasures of the unspoiled land.

Although it's difficult to say for sure when man first arrived on the peninsula, the early aboriginal inhabitants probably had little impact on the vast forests. Artifacts from a primitive village discovered at Nicolet Bay date back to about 400 BC, but anthropologists suspect that the area has been inhabited by various cultures for more than eleven thousand years. Nicolet Bay, in fact, was named after the first white man to set foot on the land, a young French explorer named Jean Nicolet.

Nicolet arrived in Canada in 1618 to work in the French colony known as "New France" (now Quebec) under the auspices of Governor Samuel de Champlain. He spent a great deal of time living with the indigenous tribes of the area, first with the Algonquins and later with the Hurons during the time when France was temporarily deposed from power by the British. Nicolet was clever and fair and earned the respect of the natives. He also paid close attention when his Indian friends spoke of a tribe to the south whom they called the Puans, or "People of the Sea." Nicolet was convinced that this legendary tribe guarded the fabled Northwest Passage, a mythical water route that would lead directly across the North American wilderness to China.

When the Treaty of St. Germain returned New France to the French and restored Governor Champlain to power in 1632, Champlain sent the brash voyager to the territory that is now Door County in a quest to seek out the coveted passage. Nicolet and some Huron Indian guides came ashore on Eagle (Horseshoe) Island in the summer of 1634, just off the coast of present-day Peninsula State Park. The Hurons knew that the Puans—actually Winnebagos, or Hochungaras (Ho-Chunks)—had a huge settlement on the Green Bay shoreline, just north of the present-day town of Green Bay in an area known as Red Banks.

The Winnebagos had a reputation as a fearsome and warlike tribe, and Nicolet was gambling that he could win them over. He sent two of his guides ahead to announce the visit, which would be the Ho-Chunks' very first encounter with a white man. Unfortunately, language was a brief stumbling

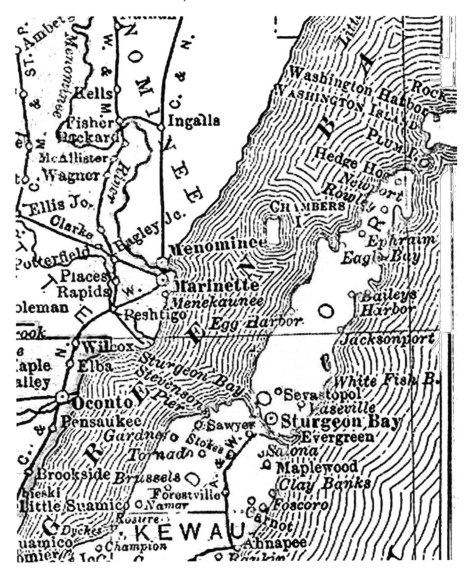

An 1895 map of Door County shows a largely unsettled wilderness, with only a handful of towns.

block. Although Nicolet was fluent in the Algonquian dialect that was spoken by the Hurons and other eastern Great Lakes tribes, the Winnebago people spoke a Sioux dialect. Nevertheless, Nicolet approached them with a friendly manner and a bit of theatrics designed to win their respect. Reports from the time say that he landed his canoe at their settlement and stepped out

dressed in a flamboyant Chinese-styled long silk coat covered with colorful embroidery, a pistol in each hand. He fired the pistols into the air, frightening and intriguing the people, who had never before seen firearms. And then, with a grand flourish, he laid down gifts for his new acquaintances.

The Indians, although perhaps slightly dubious, welcomed Nicolet into their community. Nicolet, for his part, mistook the subtly different facial features of the Ho-Chunks for Asian and briefly believed that he had succeeded in his goal of reaching the Far East. Although he was momentarily disappointed when the Indians explained that they had no knowledge of Asia, he quickly recovered when he realized that he had instead stumbled into a pristine wilderness teeming with fish, hardwood forests and fur-bearing mammals such as beaver and mink. Nicolet and his guides lived peacefully among the Ho-Chunks for the winter and were treated as valued guests until their departure the following spring. Upon his return to Canada, Nicolet informed Champlain of his discoveries, but the governor died soon after, and no major explorations took place for many years until a stream of missionaries, fortune hunters and fur traders began to traverse the peninsula later in the 1600s.

Shortly after Nicolet's expedition, a series of wars broke out among the various Indian tribes of the area, and the Winnebagos lost their hold on the territory and were forced westward, where they settled in the Fox River Valley and around the large inland lake that now bears their name, Lake Winnebago. Door County became the land of the Potawatomis, a friendly tribe of Algonquin descent. The Potawatomis (sometimes spelled as "Pottawatomies") built a large settlement at the mouth of Hibbard's Creek, near the current town of Jacksonport. The heavily fortified village was known as *Méchingan* and quickly became a haven for other beleaguered tribes on the run from their enemies. The Ottawa and Huron people of Washington Island, fleeing an imminent attack by a massive war party of Iroquois, took refuge among the kindly Potawatomis and were able to outlast the aggressors, who were eventually driven back by starvation. The Potawatomis also saved many explorers and traders who came to the area ill-equipped to survive the fierce winters, including the renowned French explorer Robert de LaSalle.

In 1679, LaSalle and his men were on an expedition aboard his grand new ship, *Le Griffon*, to trade for furs and explore the Mississippi. At a stop in Mackinac, several of the men deserted. LaSalle left his trusted lieutenant, Henri de Tonti, behind to deal with the personnel issues, with plans to rendezvous later. Meanwhile, LaSalle and the remaining crew

sailed on to Washington Island, where a great number of Potawatomis awaited him, including their revered head chief, Onanguissé. LaSalle and Onanguissé had encountered each other several times previously and had a great deal of respect and affection for each other. By all accounts, the visit was a resounding success. In early September, *Le Griffon* sailed back toward Montreal heavily laden with furs to appease LaSalle's creditors and procure new supplies. The Potawatomis were quite pleased with their end of the bargain as well—the French traders had brought them important and practical items such as fishhooks, guns, gunpowder, knives, kettles and other tools, as well as some fancy adornments such as beads and brightly colored coats. LaSalle remained on Washington Island with a small contingent of men, awaiting the return of his ship.

Unfortunately, *Le Griffon* would never return. On the trip back toward the territory that is now Michigan, the vessel encountered some seemingly

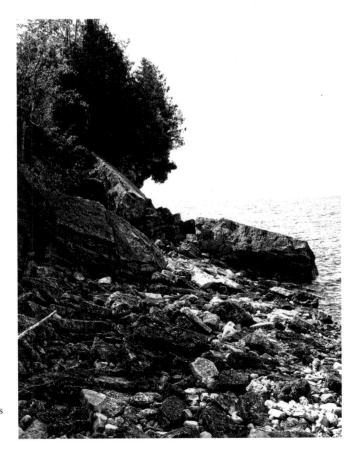

A typical rocky shoreline in Door County, as wave action tumbles blocks of dolomite. *Photo by Peter Rimsa.*

friendly Ottawa and Huron tribesmen. Some of these Indians were familiar to the crew from earlier trips to the area, and they were invited aboard. What the crew didn't know was that some instigators had convinced these tribes that the enormous sailing ship was secretly looking for slaves and also intended to take over the fur trade and starve out the natives. In an act of misguided paranoia, they killed the crew and burned the ship.

Although LaSalle had no way of knowing what had happened, it eventually became obvious that the ship wasn't coming back, and he and his men decided to continue on their quest by canoe. They were accompanied by three priests serving as missionaries to the new frontier. The small armada struck out along the treacherous and rocky east coast of the Door Peninsula, buffeted by winds and storm. Travel was slow, and the relentless waves tired the weary explorers. By now it was early October, the weather was turning frightfully cold and they were out of provisions. Exhausted and starving, they made land at a rocky promontory south of present-day Sturgeon Bay. In order to reach the shore, they had to jump into the freezing water and carry their canoes safely above the slippery, sharp rocks. One elderly priest, who was far too frail to navigate the crashing surf on his own, had to be carried on the back of another much younger priest.

By the time they set up a humble camp and got a fire going to warm their fatigued bodies, they saw another danger: a fully armed hunting party of about twenty Indian braves had quietly surrounded them in the nearby forest. LaSalle, knowing that he had neither the resources nor the strength to repel an attack, slowly approached the warriors and did his best to show that he meant no harm. To his great relief, the Indians were friendly Potawatomis, who quickly assessed the explorer's dire straits and sent some members back to their village for supplies. They returned with so much food that it threatened to overload LaSalle's canoes. In later writings, LaSalle credited those Indians with saving his life and the lives of his companions. Thus fortified, they completed their trip safely down the lakefront and on toward the Mississippi.

In an odd twist of fate, the Potawatomis also ended up saving the life of Henri de Tonti, LaSalle's lieutenant whom he had left behind in Mackinac months earlier. Tonti had cobbled together a small contingent of men to replace the deserters, and he and the new recruits traveled by land down through Michigan and across Illinois, hoping to meet up with LaSalle at the Mississippi. Once they reached the mighty river, they began the backbreaking task of constructing a new boat to carry them on the expedition.

However, in a sad repeat of history, these men also deserted, leaving Tonti with just a handful of loyal companions and few supplies. In desperation,

they turned to a friendly tribe of Illinois Indians for shelter during the approaching winter. No sooner had they settled in when a war party of more than six hundred Iroquois attacked the Illinois tribe. Tonti and his men were taken captive but later released without supplies or provisions on the bleak and freezing Illinois prairie. They struggled northward with only a leaky canoe, hoping to find a friendly settlement. Eventually, they reached the Potawatomi village of *Nahmamequetong* on the shores of Green Bay. This was the home of Chief Onanguissé, but the village was deserted because the Indians had moved to their winter hunting grounds. Although the cabins were well stocked with firewood, there was no food to be found.

Desperate, the explorers continued north, but starvation and the mind-numbing cold drove them back. They decided to return to the deserted settlement, where at least they could die warm in the sheltering cabins. In a stroke of good fortune, as they approached the village they stumbled into the path of some Potawatomis passing through the area on the way back from a hunt. The Indians immediately fed the starving Frenchmen and stayed with them until they were strong enough to move. They then loaded the men into their canoes and brought them to the winter campsite, down the bay near the present village of Little Sturgeon Bay. Here they safely spent the winter, along with some other French fur traders who were enjoying the tribe's kindness and hospitality. In spring, Tonti and his colleagues returned safely to Mackinac, where they reunited with LaSalle. The following year, LaSalle and Tonti set out once again and finally achieved their goal of exploring the Mississippi all the way south to the Gulf of Mexico.

Although the seventeenth and eighteenth centuries saw a great flurry of exploration and fur trading in the region, the early European adventurers simply passed through and didn't settle in the area. The first white settler didn't reach the peninsula until the early part of the nineteenth century, when a young Yankee pioneer by the name of Increase Claflin built his homestead. Claflin first settled in the area of Kaukauna, Wisconsin, where he earned a living as a fur trader. He must have been quite successful, for the 1830 census shows thirteen people living under his roof—presumably many of those were hired help. In spite of this, his restless pioneer spirit was not fully at peace. He paid rapt attention when his Indian acquaintances spoke of the land to the northeast as a utopia of natural beauty and limitless resources. Intrigued, Claflin set out to visit this wondrous land and was immediately smitten. In March 1835, he bundled his family and all of his worldly possessions—including a sailboat—onto two sleds and set out across the ice of Green Bay, with his cattle and breeding horses following closely

behind. He set up his homestead at the mouth of Little Sturgeon Bay, across from a peaceful settlement of Menominee Indians. He spent nine years in this location, breeding his horses, farming, hunting and fishing to supply a comfortable lifestyle for his family. In 1844, he left the land to his daughter and son-in-law and moved the remainder of his family about twenty miles north, to a point of land that is now part of Peninsula State Park.

By the 1850s, other Europeans had begun to arrive in the area. Next on the scene was Asa Thorp, a skilled cooper (barrel maker), who built the first pier and supplied lumber for the fishing boats and paddle-wheel steamers that passed by on their way to the Green Bay settlement. Thorp later founded the village of Fish Creek. Soon, Norwegian Peter Weborg settled nearby with thirty-five other families, heralding the beginning of a large influx of Nordic immigrants. By the 1860 census, 1,948 nonindigenous people lived on the peninsula, and that number had grown to 15,082 by the 1890 census. Most of the Potawatomi and other tribal inhabitants were forced out by the federal government under the Indian Removal Act of 1830. Stripped of their land and crowded onto reservations, Onanguissé's descendants must have felt betrayed by the white men they had so generously helped centuries before.

THE PROPHESY OF THE DOOR

O, I have suffered with those that I saw suffer! A brave vessel…dashed all to pieces! O, the cry did knock against my very heart! Poor souls, they perished!
—The Tempest, *William Shakespeare*

The Porte des Mortes passage, or "Death's Door," has earned a rightful reputation as a mariner's nightmare. Sudden, unpredictable squalls, erratic wave patterns and shallow shoals have combined to drag many a proud ship to a watery grave. Gales blow up out of nowhere, only to subside as quickly as they appear. Wooden ships of old were not as maneuverable and often found themselves trapped in the narrow straits, dashed to bits by the waves within easy sight of shore. Even the boatmen of today, piloting sleek, powerful vessels equipped with sophisticated navigational tools, treat the waters around "the Door" with a mixture of respect and caution. It only takes one momentary lapse in judgment, one careless oversight, to risk joining the legions of those who underestimated the wrath of the temperamental waters.

It's not just the strait that is dangerous. Most of the peninsula is surrounded by shallow, rocky ledges that jut out into the lake, as well as hidden shoals where an unsuspecting boat can bottom out in the waves. Of course, modern navigational maps and depth-sounding equipment mitigate much of the danger today, but earlier visitors to the area weren't as lucky. As mentioned previously, some experts claim that the waters of Door County hold more shipwrecks than any other body of fresh water in the world. There are 213 that have been identified and listed, but the count is likely much, much

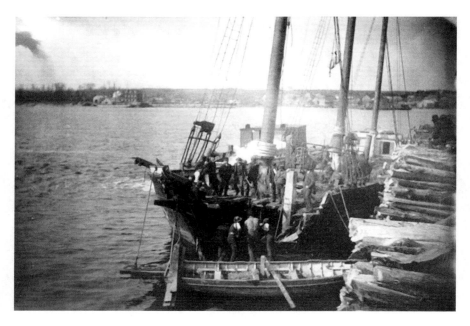

Workers at Sturgeon Bay repair the damaged hull of a schooner.

higher. Most of these listed are larger vessels that sank within the past few hundred years; it doesn't count the unknown numbers of long-ago Indian canoes or humble skiffs that disappeared beneath the waves without any notice or fanfare.

Not all the wrecks resulted in a loss of life. Some sailors escaped the icy waters and lived to record the history of their travails. A few wrecks happened just off the shoreline, leaving the ship's skeleton to tell the tale long after the mortals had slipped away. One of the most famous is the *City of Glasgow*, which carries the distinction of being the only ship that sank in the Door's waters not once, but twice! The *City of Glasgow* was first launched in 1891 in West Bay City, Michigan. It was considered one of the finest of its day, with a length of 297 feet, 41-foot beam and drawing 21 feet. Powered by two 11-foot by 13-foot boilers that delivered 150 pounds of steam, the ship was the largest on the Great Lakes and became the core of the Pioneer Steamship Company fleet, towing barges filled with coal, iron ore and grain between Chicago, Duluth and Buffalo.

During a fierce gale in November 1907, with a load of coal bound for Green Bay, the *Glasgow* ran aground on a reef near Peshtigo, Wisconsin. Rescue tugs were able to drag it off the reef after jettisoning most of the

By Land and Water

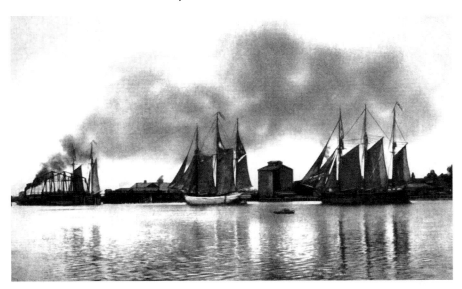

Lake schooners carried freight and passengers across the Great Lakes.

cargo, but the hull was seriously damaged. The ship limped into Green Bay for repairs, but its troubles were far from over. In early December, while moored in the Green Bay ship channel, the *Glasgow* caught fire and sank. The following spring, John Leathem and Thomas Smith purchased the wreck. Leathem and Smith owned a very successful dolomite quarry just north of Sturgeon Bay and knew that a sturdy ship like the *Glasgow* would be an asset for hauling stone. Once the ship was raised and towed in for repairs, however, the new owners realized that the damage was too severe to return the steamer to its original condition. Instead, they opted to remove the boilers and other hardware and turn the hull into a barge. The fire-damaged stern was removed and replaced. They sold the engine for $3,000, which was quite a windfall at the time. Other parts were traded off or sold for scrap. Thus, with some repairs and minus power, in 1911 the *City of Glasgow* returned to the waters of the Door as a humble stone barge.

As a barge, the once proud ship was still a workhorse, carrying cargo between the Great Lakes ports under tow by the large tug *Hunsader*. Completing the successful team was another barge, the former schooner *Adriatic*. The *Adriatic* was built in 1889 in the same Michigan village that built the *Glasgow*. At two hundred feet in length, and with a thirty-five-foot beam, the three-masted schooner was fast and sleek. Unfortunately, the advent of the faster and more powerful steamers made schooners archaic, and the

Adriatic lay idle for a few years until Leathem and Smith purchased it in 1913 to work alongside the *Glasgow*. The *Adriatic* was a first for Leathem and Smith, as it had been outfitted with new technology that allowed it to self-unload its heavy cargo. The concept of self-unloading was simple yet brilliant and saved many hours of backbreaking manual labor. The cargo holds were fashioned into a funnel shape, with hatches that opened onto a conveyor belt inside the ship. When the hatches were opened, gravity pulled the crushed stone or iron ore cargo onto the conveyor, where it traveled to the rear of the ship, into a hopper and then onto an unloading boom. Self-unloaders revolutionized the shipping industry, allowing heavy cargos to be delivered quickly and efficiently, and the *Hunsader* and its two barge consorts made for a formidable team.

On October 4, 1917, the crew delivered a load of Door County limestone to a dock in Chicago and headed north for the trip back home. For most of the voyage, the weather was pleasant and cooperative. As they steamed north of Kewaunee on October 6, however, the winds from the south began to increase ominously, kicking the lake into a mass of frothing waves. At about 7:00 p.m. that evening, the trio reached the Sturgeon Bay ship canal. As the *Hunsader* attempted to navigate into the narrow canal, the towlines to the barges snapped, casting the *Glasgow* and the *Adriatic* and their crews adrift into the roaring gale. Captain Serface, the commander of the tug, knew that he couldn't safely chase down the two renegade barges in the vicious storm and the shallow surf, so instead he headed directly to the Coast Guard station near the mouth of the canal and reported the emergency.

When the commander of the *Adriatic*, Captain Chris Olson, saw that they had lost the tow, he immediately cut the line that connected his ship to the *Glasgow* and dropped all anchors. The *Glasgow*, which was much lighter in weight, was being tossed about like a cork. Even under full anchor, however, the relentless waves continued to drive the two helpless ships toward the beach. The barges crashed together with the rise and fall of each wave as the crews struggled to stop the slow march toward the rocky shoals. Eventually, the *Adriatic*'s dragging anchors finally caught a grip, and the ship swung around facing the wind, where it could ride out the storm in relative safety if not comfort. The *Glasgow* was not as lucky and was pushed almost onto the beach. About midnight, the Coast Guard managed to pass a line to the *Glasgow* and rescue its two crewmen, but the ship could not be saved. It sank just a few hundred feet offshore in about ten feet of water. The waves broke the *Glasgow* in half at the point of its previous repair, and now only the bow portion remains, pointed directly at the shore it never made. The *Adriatic*

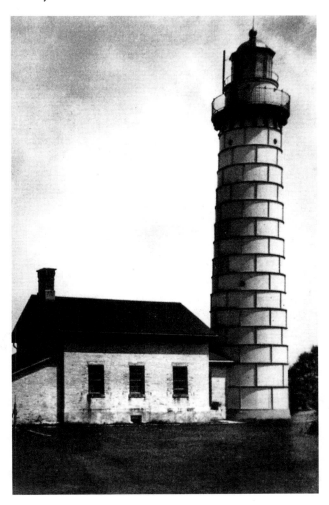

Cana Island Lighthouse. The tower was actually constructed from the same brick used in the keeper's house, but it was later covered in steel plates due to deterioration from wind and waves.

crew was rescued at daylight as the storm subsided, and the ship itself only needed some minor repairs before once again being declared seaworthy.

Today, the remains of the *Glasgow* are clearly visible from the surface, and during some periods of low-water levels on the lake, parts of the wreck have been exposed. It's a common attraction for snorkelers and divers and a reminder of the capricious nature of Lake Michigan's waters. The *Adriatic* was returned to service until 1927, when advancing technology and the old schooner's age made it economically unsuitable. After a few years of being tied up at the old Smith Company Dock in Sturgeon Bay, it finally sank in the harbor in 1930. Like the *Glasgow*, the *Adriatic* is also a popular dive site.

Another of the Door's well-known wrecks is the freighter *Frank O'Connor*. The wooden steamer was 301 feet long, with a 42-foot beam, and held the distinction of being one of the largest wooden ships ever constructed. Built in West Bay City, Michigan, just a year after the *Glasgow*, the *O'Connor* was originally named the *City of Naples*. After many years of working the Great Lakes, it was purchased by the O'Connor Transportation Company in 1916 and renamed after the owner's son. In May 1918, tragedy struck the O'Connor family when young Frank died on a German battlefield during World War I. Less than two years later, his namesake would also meet an untimely demise.

In September 1919, the ship was carrying a cargo of hard coal from Buffalo, New York, bound for Milwaukee. Most of the trip was uneventful, marked by perfect sailing weather. Even the waters of the Door were exceptionally cooperative, with light breezes and calm seas. On the late afternoon of October 2, the *O'Conner* steamed toward North Bay in Baileys Harbor, abreast of the Cana Island Lighthouse. The weather was pleasant, they were within a day or two of their destination and most of the crew unhurriedly went about their chores as the sun slipped lower in the sky.

Suddenly, a crew member noticed a plume of smoke coming from the vicinity of the paint and oil house in the ship's bow. The crew rushed forward with firefighting equipment, but the hungry flames ate away at the wooden vessel, undeterred by their efforts. The ship's captain, William J. Hayes, ordered the wheelman to make for shore. They were still ten miles from land, however, and before they could reach the shallow waters, the fire consumed the ropes that controlled the steering mechanism. The *O'Connor* was now adrift and aflame. Hayes commanded his crew to board the lifeboats and ordered the engineers to open the seacocks and flood the steamer. The three thousand tons of coal aboard had a value of about $30,000 at the time (nearly $400,000 in today's dollars), and Hayes knew that sinking the ship and its cargo before it burned would allow a later salvage attempt. As the crew watched helplessly from the lifeboats, the *O'Connor* slipped beneath the peaceful waters and came to rest about 2.5 miles northeast of Cana Island in sixty-five feet of water.

While the drama was unfolding out in the lake, Cana Island Lighthouse keeper Oscar Knudson and his assistant, Louis Pecon, had spotted the smoke and flames on the horizon and headed out in a powerboat to assist. They found the flotilla of lifeboats manned by the exhausted crew rowing toward shore and fastened lines to tow them to safety. Just as they reached the lighthouse, the Coast Guard from the nearby lifesaving station in Baileys

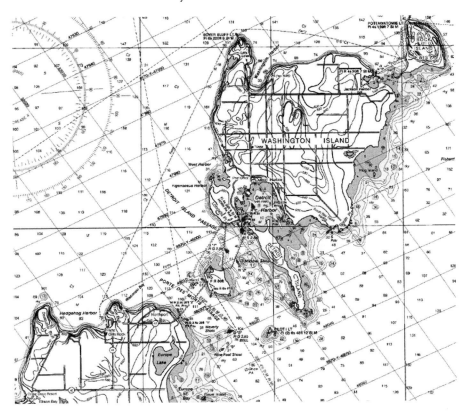

An old map of the Death's Door passage. Markings clearly illustrate the wild variations in depth around the peninsula, which can go from fearsome depths to extremely shallow shoals and ledges in a short distance.

Harbor arrived on the scene and escorted the twenty-one weary sailors to the station for a hearty meal and a good night's sleep. The next morning, they were transported to Sturgeon Bay until they could be returned to their homes.

In the aftermath, United States Steamboat Inspection Service members held a hearing on the cause of the fire and ultimate sinking. Although the *O'Connor*'s oil room and paint lockers were obvious suspects, especially due to the first reported location of the flames, they had been properly housed inside steel compartments and were unlikely to have caused the conflagration. A final cause was never determined, but the investigators had some theories. The ship had spent much of the summer hauling grain on the Great Lakes, and highly flammable grain dust had likely built up in every nook and cranny. One carelessly tossed cigarette or stray spark would have been all that was needed to kindle a fire on the old and heavily varnished wooden ship. In any case,

Captain Hayes was absolved of all blame, and investigators credited his quick thinking in scuttling the ship with saving the valuable cargo. The next summer, a Milwaukee salvage company recovered about seven hundred tons of coal from the wreck, and another attempt in 1935 salvaged another one hundred tons. After 1935, the location of the wreck site was forgotten for several decades, until it was rediscovered by sport divers in 1990. In 1994, the *Frank O'Connor* shipwreck was listed in the National Register of Historic Places. Today, a buoy marks the site, and scuba tours bring divers to explore the massive boilers and prop that sit upright on the lake floor, surrounded by scattered chunks of coal that remain in silent testimony from a long-ago disaster.

Although ships were lost with alarming frequency in the waters around the Door, some fierce storms drowned ships en masse. One of the worst storms in history occurred over a two-day period in October 1880 and is known as the "*Alpena* Gale" in reference to a side-wheel steamer that went down in the storm with eighty people on board. It was last seen on October 16, foundering in the waves just north of Kenosha, Wisconsin. A few days later, debris and two bodies washed up onshore on the opposite side of the lake near Holland, Michigan. Although the wreck has never been found,

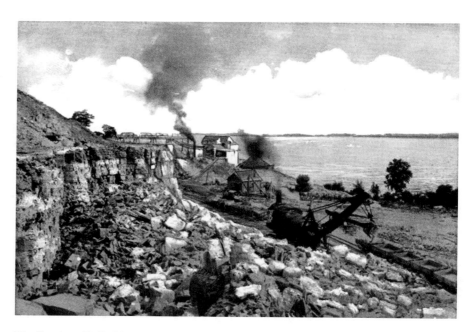

The Leathem D. Smith stone quarry mined huge blocks of dolomite. These giant stones line Chicago's harbors to this day. Smith also sold crushed stone for building purposes.

an eerie reminder of its loss rose from the watery depths in an ironic twist nearly thirty years later. In January 1909, beachcombers walking the shores of Alpena Beach in Michigan came across a chilling discovery: the side-wheel name board of the doomed ship had washed onto the shore of its namesake beach after decades beneath the waves. The *Alpena* is on the "most wanted list" of the Michigan Shipwreck Research Associates group, whose members hope to locate its final resting place.

The *Alpena*, however, was far from being the only ship to founder in the 1880 gale. Winds onshore were estimated at 125 miles per hour, and monstrous waves made short work of any ship foolhardy enough to be on the water. At Cana Island Lighthouse, the waves roared so high that they swept over the roof of the brick two-story keeper's house and reportedly splashed onto the lantern glass in the tower, almost eighty feet above lake level. Keeper Warren Sanderson and his family took refuge in the boathouse farther inland on the island, as lake water swirled through the kitchen and first floor of their home and threatened to sweep them all into the angry surf. The family's chickens were all drowned, walkways were destroyed and anything not lashed down was smashed to bits. During the storm, at least seven ships sank in the waters off Cana Island before they could reach safe harbor, and perhaps as many as thirty more went down or were driven ashore near Plum Island Lighthouse at the entrance to Porte des Mortes passage. The gale destroyed so many ships that some of the wreck sites were just jumbled piles of timber, with little indication of the original vessel from which they came. Due to sketchy record keeping from the era, there are no reliable records of casualties, but historians agree that it was one of the deadliest storms in Great Lakes history.

In November 1913, another massive gale hit the waters of Door County. This one, nicknamed "the Big Blow," was better documented and slightly less severe that the *Alpena* Gale. Twenty vessels sank around Door County during the storm, and seventy-one more were damaged. Sustained winds of seventy-five miles per hour drove a blinding snow across the water as ships struggled for harbor. About 250 mariners died in the storm, and millions of dollars in damage was incurred. One of the most famous wrecks was the *Louisiana*, a second-generation bulk carrier from Cleveland, Ohio, that was traveling through Death's Door on its way to Escanaba, Michigan, to pick up a load of iron ore when the storm began. Its captain, Fred McDonald, decided to seek shelter in Washington Harbor on the shore of Washington Island. Unfortunately, the *Louisiana*'s anchors couldn't hold the ship in the violent waves and wind, and the storm pushed the craft aground near the

rocky southeast shore of the harbor. Although a mere stone's throw from land, the crew knew that they would be dashed to death on the rocks in the pounding surf if they tried to abandon ship in their small lifeboat.

Instead, they chose to ride out the storm overnight aboard the mortally wounded steamer. By morning, however, the situation had deteriorated. The battered *Louisiana* had now caught fire, and with wind-driven flames howling at their backs and deadly breakers blocking their access to shore, the crew had few good options. Finally, they were forced by the fire to take their chances on the lifeboat. By this time, rescuers from the U.S. Life-Saving Service station (the precursor to the Coast Guard) on Plum Island had arrived on foot after a grueling trek over land, dragging their small boat and other equipment across the snow-covered ground. The waves were so powerful and overwhelming, though, that entering the water seemed like a suicide mission, and the would-be rescuers could do nothing but watch helplessly and pray as the *Louisiana*'s crew struggled in the maelstrom. Miraculously, the frenzied waves lifted up the small lifeboat and dumped it unceremoniously onshore, where the wet, freezing and frightened sailors scrambled to safety. Today, the *Louisiana*'s hull rests in about eighteen feet of water near Washington Harbor and is accessible by snorkel or kayak. Like the *Frank O'Connor*, the *Louisiana* is listed in the National Register of Historical Places.

Although the 1880 and 1913 storms claimed hundreds of lives and resulted in severe property losses, they weren't considered unusual. Shipwrecks were just an expected part of life on the peninsula. In one single week in 1872, almost one hundred vessels were lost or seriously damaged passing through the Door during foul weather. Even in fair weather, a certain number of ships were bound to meet their doom on the jagged coastline. Although new shipwrecks are rare these days, the perilous waters still command respect. Should any modern-day mariner forget the power of Death's Door, he or she only need to visit one of the myriad wreck sites that surround the county or listen to the ominous howling of the wind from a high bluff, sounding much like the cries of the lost as yet another storm descends on the unpredictable waters.

LIGHTHOUSES

Beacons of the Storm

*Alone! Alone! No beacon, far or near! No chart, no compass,
and no anchor stay!*
—English writer Ada Cambridge

As settlers moved to the peninsula and merchant ships began to ply the waters in earnest in the early 1800s, it quickly became obvious that lighthouses were needed to warn approaching ships of the impending danger from hidden shoals and rock-strewn harbor entrances. Although lighthouses had existed on Lake Erie since 1818, Lake Michigan had none. Finally, in 1836, the newly created Territory of Wisconsin contracted to have Wisconsin's first lighthouse built on a bluff on the northern coast of Rock Island. The strait between Door County's Rock Island and Michigan's St. Martin Island was considered the widest and safest passage between Lake Michigan and Green Bay, much safer than the dreaded Porte des Mortes passage to the south. The Rock Island passage was not without perils, however, as it shared the same rocky coastline as the rest of the Door. For the handsome sum of $8,000, builder Michael Dousman agreed to construct a lighthouse and dwelling on the bluff, using rock quarried from the island.

In 1837, the construction was completed. The light was named the Potawatomie Lighthouse in honor of the Indian tribe who had long inhabited the area. The name was especially fitting, because "Potawatomie" translates loosely into "keepers of the fire," or "people of the place of the fire." The thirty-foot stone tower measured eighteen in diameter at the base, tapering to nine feet just below the lantern. The light itself was based on the lamp patent of Winslow Lewis, an unemployed ship captain from

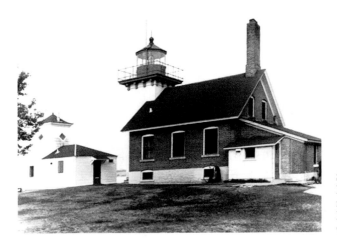

Sherwood Point Lighthouse welcomes mariners in the Sturgeon Bay Ship Canal from Green Bay.

Cape Cod, and included eleven oil-burning lamps backed by fourteen-inch reflectors. Although these smaller individual lamps performed slightly better than the common spider lamps of the day (one large oil pot with multiple wicks), the Winslow lamps had many shortcomings. They gathered soot and required frequent cleaning, and the thin, silver-coated copper reflectors often distorted under the heat and failed to reflect the light properly. The Winslow lamps were estimated to be four hundred times less bright than the type commonly used in Europe, which were designed by a French inventor named Ami Argand. Argand lamps were fitted with a large, hollow, circular wick that burned much brighter due to airflow along and inside the wick. The lamp was then placed into the center of a sturdy twenty-inch parabolic reflector, casting a bright light many miles out to sea.

Winslow had seen the Argand lamps during his travels and created an alternate design that he touted to the United States government as an economical and improved version of Argand's invention because the new Winslow Patent Lamps used 50 percent less oil. The fact that they also cast four hundred times less light was somehow overlooked by Congress, because in 1812 Winslow Lewis was awarded a contract to refit all of the lighthouses in the United States. What Lewis lacked in ingenuity he apparently made up for in salesmanship. His design remained in use until the mid-1850s, when the newly designed Fresnel lens lamps were phased into American lighthouses. Designed by another French inventor, Augustin Fresnel, the new lamps used a large glass barrel composed of multiple prisms. This barrel would be placed over a single light source (lamp), and the light would then be refracted and

reflected through the prisms until it emerged in a single horizontal sheet of magnified light. This new design reflected about 80 percent of a light source, versus 20 percent reflection from the old parabolic system used by Winslow and Argand. The Fresnel lenses were originally designed in six "orders," or sizes. First orders were the largest and most powerful and typically were used on coastal lighthouses. The smaller fifth or sixth orders were more common in harbors and bays. In 1858, the Potawatomie Lighthouse was refitted with a fourth-order Fresnel that greatly improved the beacon's range and visibility.

The first light keeper at Rock Island was David E. Corbin, a former fur trapper and veteran of the War of 1812. Corbin was a bachelor, with just a dog and a horse for company. Officials worried about his state of mind during the long lonely winters, and in 1845 they granted him a twenty-day leave of absence so that he could go out and find a wife. Apparently, wives were a little harder to trap than the small mammals he was used to, and he returned to the island empty handed. By the 1850 census, however, the lighthouse was fairly crowded. A widow named Catharine Storce had moved in with her three children, and a young laborer by the name of William Kingsley also resided there. Unfortunately, Corbin didn't get to enjoy all of this company for long. In December 1852, after a short illness, he passed away. They buried his body in a grave site just south of the lighthouse he so loved.

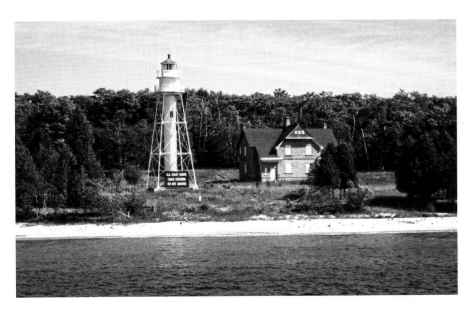

An automated rear range light and keeper's quarters on Plum Island. The island is now part of the Green Bay National Wildlife Refuge. *Photo by Peter Rimsa.*

By 1858, the original tower and dwelling had badly deteriorated. It seemed that the builder, Dousman, had used a poor mortar, and water was seeping into the structures. Falling plaster and continual dampness had plagued the compound, and finally the government decided to tear everything down and rebuild. The new building was a great improvement. The crews blasted a basement out of the rocky cliff and built a new two-story stone residence topped with a square wooden tower and lantern room. The lighthouse is still in use today, although it was automated in 1946 with the advent of wet cell batteries. In 1986, the batteries were replaced by solar panels, and in 1988, the old lantern room was abandoned in favor of a new steel skeleton tower built nearby. The 1858 building was restored as a lighthouse museum, however, complete with a replica Fresnel lens like the original. It is open for tours during the summer and can be accessed by tour boats from Washington Island.

Door County's second lighthouse was built in 1852 on a tiny island near the mouth of Baileys Harbor. Alison Sweet, an entrepreneur who had constructed a sawmill and quarry nearby, petitioned Congress for the funds to build a small lighthouse that would safely guide boats past the rocky entrance to the harbor. Congress agreed, and Sweet was awarded the contract. Due to very low lake levels that year, Sweet's men were able to reach the island by foot, wading through the shallow waters. They built a 52-foot tower out of stone taken from Sweet's quarry and topped it with a wire birdcage-style lantern room equipped with a sixth-order Fresnel lens. In 1858, it was upgraded to a more-powerful fifth-order lens. Unfortunately, by 1866, the structure had seriously deteriorated from the elements. After some discussion, the federal

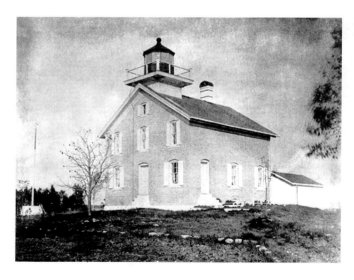

The Pilot Island, or Port des Morts, Light Station as it appeared in the early 1900s.

By Land and Water

Lighthouse Board decided to abandon the building in favor of range lights for the harbor and a more powerful lighthouse for the coastline. At the close of the shipping season of 1869, the "birdcage" (as it is known) shone across the waters for the last time. The island, which measures a mere 250 feet by 1,000 feet, is now privately owned and not open to the public. The tower still stands, however, and is visible from the mainland or from various charter tours, and it remains a popular landmark for visitors to Baileys Harbor.

The same year that the birdcage lighthouse was closed, construction began on the new harbor range lights. The concept of range lights is simple: the rear or "upper" light shines a white beacon directly out into the lake, while the "lower" or front range light shines a red beacon on a lower focal plane. To safely enter the harbor, a ship's captain needed only to steer his vessel so that the white light appeared to be sitting directly on top of the red. If the red light seemed to drift left or right, then that meant the ship was off course and the captain needed to adjust his path to bring the lights back into alignment. The Baileys Harbor Range Lights were built on the northwest corner of the harbor, allowing ships approaching from the south to have plenty of time to see them and steer a proper course. Baileys Harbor was at that time the first protected port between Milwaukee and the tip of Door Peninsula, and it served as an important haven for storm-battered ships.

The rear range light was a combination keeper's house and light. The white clapboard dwelling is twenty-four by thirty-six feet and includes seven rooms and a large front porch. A small square tower on the front gable of the red-shingled roof was equipped with a white fifth-order Fresnel. Because range lights are designed to cast a narrow band of focused light, the tower is not glass-sided like most lantern rooms. Instead, it was built with a large window facing the lake, from which the Fresnel cast light at a focal plane thirty-nine feet above the water. The front range light is situated about nine hundred feet forward from the rear light and sits much nearer the brush-covered shoreline. The front light was built on an eight-foot-square base that is topped by a smaller octagonal tower, and it used a fifth-order red Fresnel to shine light at a twenty-two-foot focal plane. Like the rear tower, the forward lantern room has a large window facing the lake, with a much smaller window viewable from the house. This allowed the keeper to have visibility of both lights at all times, whether he was in the front or rear structure.

In 1923, the lights were converted to an unmanned acetylene gas system, and the keeper, Henry Gattie, was transferred to the nearby Cana Island Lighthouse. The buildings sat vacant and quiet until 1930, when the acetylene system was replaced with electricity. At that time, the Lighthouse

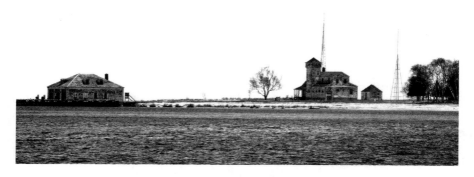

A deserted U.S. Life-Saving Station on Plum Island. Volunteer groups are working to restore the buildings, which deteriorated due to neglect and due to damage from huge colonies of nesting shorebirds. *Photo by Peter Rimsa.*

Service allowed the Immanuel Lutheran Church of Baileys Harbor to use the old keeper's house as a parsonage for its pastor and his family, and the house remained in the church's use for nearly thirty years. The land, however, became a serious point of contention between the local residents and the county. In 1934, the Bureau of Lighthouses deeded the thirty-acre tract and the buildings on it to the Door County Park Commission. The park commission board decided that the land would make an excellent spot for a trailer park and began making plans to cover the boggy landscape with gravel and stone. Townspeople were appalled. The wetlands around the range lights were home to more than 475 plant varieties, including 25 endangered orchid species, and formed the most biologically diverse area in the entire state. Birds, plants and insects of both rarity and beauty made their home in the Baileys Harbor bog.

After a vigorous campaign by area naturalists, the commission backed down and leased the land to the newly formed nonprofit Ridges Sanctuary organization. The Ridges still holds the property today, and its current lease is not set to expire until the year 2089. In November 1969, both range lights were decommissioned by the Coast Guard and replaced by a metal tower with a single directional light set closer to the shoreline. The upper range light and house now serve as offices for the Ridges Sanctuary and as meeting spots for lectures and bird-watching tours. The lower range light, which graces the shoulder of rustic Ridges Road, serves as probably one of the most photographed icons in Baileys Harbor. Both of the lights have been restored to working condition and are occasionally turned on for special events, even though they are no longer used as navigational aids.

By Land and Water

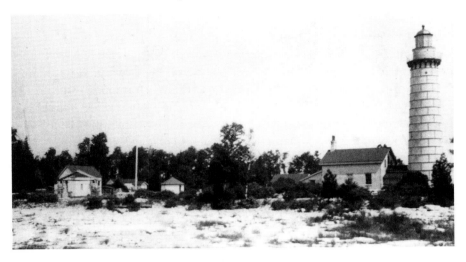

The Cana Island Lighthouse station. During the 1880 *Alpena* Gale, waves washed over the roof of the keeper's house and splashed the glass in the lantern tower.

In 1869, as the range lights were being built, construction also began for a coastal lighthouse on Baileys Harbor's Lake Michigan shoreline. The Lighthouse Board chose Cana Island, a nine-acre land mass situated off the coast between Moonlight Bay and North Bay. A lighthouse was sorely needed at that point for a few reasons. First of all, North Bay was the last protected harbor for ships approaching Death's Door, and a lighthouse would help to guide storm-tossed mariners to safety. Secondly, that area of the coastline is rife with deadly shoals and shallow underwater rock ledges. Thus, a lighthouse would serve a dual purpose as both a warning beacon and a welcoming escort. And Cana Island was a perfect location at which to build, as it is connected to the mainland by a natural causeway formed through wave action around the island. Depending on the lake levels, the rocky causeway can be wide and dry or covered with a foot or more of icy Lake Michigan water. In the 1890s, a wooden footbridge was added over the stone, but it soon fell victim to the waves. In more recent years, the footpath has been widened and remains mostly dry, but fluctuating water levels could easily submerge it once again. In any case, navigating the sometimes slippery rocks to reach the rugged island only adds to its charm and heightens the sense of adventure.

At the time the lighthouse was being built, the island itself was just a barren rocky outcropping, and builders had to add wooden walkways leading from the light to the boathouse and privy. In the early 1900s, crews hauled in topsoil and eventually planted grass. Today, trees, flowers and native grasses thrive.

The tower and keeper's house were built from cream-colored Milwaukee brick, but the tower began to deteriorate rapidly in the fearsome elements, and in 1902, it was encased in steel and painted white. The light is eighty-nine feet tall, with 102 steps from the ground to the lantern room. Its third-order Fresnel casts a beacon on an eighty-two-foot focal plane, which is visible up to eighteen miles across the waves. In fact, when it was built, the Cana Island Lighthouse was the tallest manmade structure in all of Door County.

William Jackson was appointed the first lighthouse keeper on the island, but he would only be one of many. The harsh conditions and sometimes backbreaking labor of keeping the lantern lit wore down many a caretaker. William Sanderson had one the longest tenures, from 1875 through 1891, and he and his family faced the mighty *Alpena* Gale. When he finally resigned in 1891, he called Cana Island "one of the most inhospitable and undesirable places that can well be imagined." The Lighthouse Board was aware of some of the problems and tried to make corrections.

In 1890, crews used stone and dirt to fill in more than half an acre of low-lying land in front of lighthouse and built a four-hundred-foot breakwater parallel to shore to prevent waves from reaching the dwelling. On a beautiful, sunny day with gentle lake breezes and seagulls twirling in the shockingly blue sky, it's hard to think of the island as inhospitable. When the lake becomes dark and angry, however, with waves furiously clawing at the tower, winds howling like the hounds of hell and icy needles of sleet stinging one's face, a primordial fear overtakes—only then does the work of these brave men come more clearly into focus.

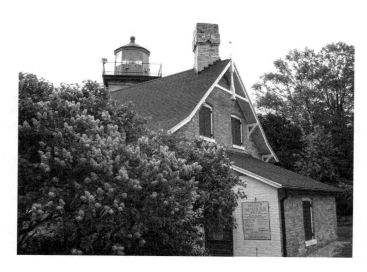

Eagle Bluff Lighthouse in Peninsula State Park. *Photo by Peter Rimsa.*

The last civilian keeper was Ross Wright, who served from 1933 until his retirement in 1941. During his tenure, there were many significant changes. Cana Island got electricity in 1934, supplied by above-ground power lines strung across the causeway. The Lighthouse Service was taken over by the Coast Guard in 1939, the same year that World War II began in Europe. During the war years, the Coast Guard used the site as a training facility, and it was closed off from the public. In 1945, the light was finally automated, and the land and house were leased to a private citizen as a summer getaway. Finally, in the 1970s, the site was leased to the Door County Maritime Museum, which maintained the property until 2007, when it was passed on to the county. Today, the land and buildings, including the tower, are open to the public. The lighthouse is still an active navigational aid and now beams its welcome light via a five-hundred-watt quartz bulb across the waters of Lake Michigan. It was added to the National Register of Historic Places in 1976 and is considered the most recognizable and photographed lighthouse in the county.

Farther north of Cana Island lay the lighthouses that guard Death's Door, Pilot Island and Plum Island. In 1846, the first light to illuminate the Porte des Mortes passage was built on Plum Island, a rugged 291-acre tuft of land that sits just south of Washington Island in the middle of the passage. It was named the "Port du Morts" Lighthouse in a slightly flawed version of the French name. Mariners quickly complained that the light was useless, as it sat too far into the channel to be of much help to approaching ships. They lobbied the Lighthouse Board, and in 1858 the board approved construction of a new light to be built on a much tinier island near the east entrance to the straits. This island was initially dubbed Port du Morts Island, but the name was later changed to Pilot Island. The original lighthouse on Plum Island was abandoned and fell quickly to the elements. By 1863, the roof had caved in, and all that remains today is a pile of rubble and stone.

The new compound on Pilot Island was built much like the Potawatomie light and others of its day, with a rectangular two-story keeper's house built of cream Milwaukee brick. A square tower perched on the western edge of the roof, topped by a ten-sided lantern room equipped with a fourth-order Fresnel. The lantern was relatively close to the ground at only thirty-five feet, but the island's elevation above lake level allowed it to achieve a forty-six-foot focal plane. Although the beacon served its purpose of guiding ships quite well under normal conditions, Death's Door has other tricks up its sleeve. Dense fogs often drape the area, rendering lighthouses virtually invisible. To combat the poor visibility, Pilot Island was equipped with a fog whistle that was powered by a caloric engine. Caloric engines used hot air to power their mechanism, but

A restored lighthouse keeper's office, displaying original furnishings. *Photo by Peter Rimsa.*

the sailors complained that the whistle wasn't powerful enough to be heard in time to be effective. In 1875, the Lighthouse Board added a steam-driven siren to the island and then added a second in 1880 to ensure uninterrupted service.

In 1904, the old steam sirens were removed and replaced with the newly patented and much more powerful diaphone fog signals. The diaphone signal ran on compressed air and produced the familiar two-tone fog warning that was heard throughout the United States and Canada until about the 1970s, when most lighthouses were automated. The diaphones on Pilot Island were so powerful that they could be heard from forty miles out. The lighthouse keepers had to run their household lighting from suspended wires or else the vibration would damage the bulbs. It also wreaked havoc with the livestock. Traditionally, the self-sufficient lighthouse keepers would raise chickens for the eggs and meat. To the consternation of Pilot Island's keepers, the vibration from the powerful foghorns killed the fragile chicken embryos in the shell, so no chickens ever hatched at the station.

The light was automated in 1962, and the Coast Guard removed the foghorns. With the advent of sophisticated radar and LORAN (Long Range Navigation, now being phased out in favor of GPS), the archaic yet familiar audible devices were obsolete. Sadly, with the keepers gone, the station fell into serious disrepair. A solar-powered 300mm lens still shines across the water, but the island itself has been taken over by a massive colony of breeding cormorants and gulls. A thick white coating of bird droppings covers most surfaces and has killed off the trees, leaving the skeletonized limbs to cast eerie shadows across the land. In 2007, the Coast Guard gave possession of the island to the U.S. Fish and Wildlife Service (USFWS), which has allowed

the nonprofit group Friends of Plum and Pilot Islands to visit the island in an attempt to rescue and restore the structures. The work is costly and difficult, but the group has done a great deal to preserve the historic site.

After the lighthouse at Plum Island was abandoned and moved to Pilot Island in 1858, officials realized that the waters around Plum still needed some navigational aids, specifically range lights and a foghorn. After five years of discussions between the Lighthouse Board and Congress, the U.S. Life-Saving Service stepped in and requested funding for a lifesaving station on the site, due to the large number of shipwrecks in the vicinity. Congress finally acted, and work began on both projects in August 1896. By that December, the crew of thirty men had built the 1.5-story lifesaving station along with a barn, a boathouse, piers, a two-story keeper's house, front and rear range light towers, wooden walkways, connecting roads and a cleared spot for a foghorn. In early 1897, a steam fog siren was installed, and the lamps were added to the range lights. The front light tower housed a sixth-order fixed red Fresnel that shone on a 32-foot plane; 1,650 feet to the north, the rear range iron skeleton tower held a fourth-order fixed red Fresnel that cast its light on an 80-foot plane. Together, they could be viewed for several miles to the south and well into Death's Door. The range lights were automated in 1969 and the fog horn removed a few years later. Today, the island is deserted, but the range lights still cast their lights across the water to guide mariners safely through the difficult channel.

Although the Lighthouse Board was originally most concerned about the rocky Lake Michigan shoreline and the Porte des Mortes passage, the growth of shipping along the Green Bay coastline created a need for lighthouses on that side of the peninsula as well. In the late 1860s, Congress approved funding for two new towers, one on Eagle Bluff in Fish Creek and the other on Chambers Island. The residences were built to nearly identical specifications, using the same cream-colored Milwaukee brick used on other light stations. Only the towers differed significantly, so that sailors could easily distinguish between the two stations in daylight. Eagle Bluff was constructed with a nine-foot square brick tower and topped by a ten-sided, seven-foot-square, cast-iron lantern room that originally housed a 3½-order Fresnel lens built in Paris. The light shone at a seventy-six-foot focal plane and was visible for up to sixteen miles across the water. In 1918, it was replaced by a fifth-order Fresnel and later automated, in 1926. For years, the building sat mostly vacant, but in 1963 the Door County Historical Society opened the renovated structure as a museum. It is an active navigational aid.

Chambers Island lies a bit over seven miles from Fish Creek to the east and about twelve miles from Marinette, Wisconsin, on the west. Most of

the old ships sailed to the wider western passage rather than risk the rockier and narrower passage along the Door County coast. With that in mind, the planners situated the new lighthouse on the northwest corner of the island. The tower stands three stories tall, with a ten-foot-square base topped by an octagonal deck below the lantern room. The tower housed a fourth-order Fresnel, casting its light at a sixty-eight-foot focal plane. In 1961, the Coast Guard removed the lantern and replaced the light with a ninety-seven-foot-tall steel skeleton tower that is powered by solar panels. The grounds are now maintained by the Town of Gibraltar as a park.

The last lighthouse to be built on Door County's western shore is located at Sherwood Point, near the mouth of Sturgeon Bay. As construction progressed on the Sturgeon Bay Ship Canal, officials realized that ships entering the canal from Green Bay would benefit from some assistance in navigating the relatively narrow channel. Congress approved funding in 1881, but it took until 1883 before the Lighthouse Board secured title to the land site. Unlike the other lighthouses of the county, Sherwood Point was built using red brick, so the building looks quite a bit different from its peers. It consists of a two-story, twenty-five- by thirty-seven-foot residence, with attached light tower. The original lantern room contained a complicated apparatus that displayed a fixed white light alternating with a flashing red light. It was visible for about fifteen miles, at least when it actually worked. Unfortunately, it frequently broke down, and in 1891 the exasperated Lighthouse Board scrapped the whole mechanism and replaced it with a fourth-order Fresnel lens cobbled from the Passage Island light in Lake Superior. In 1892, the board also added a fog signal to the station. Conrad Stram, the last civilian keeper of the light, retired in 1945, and the Coast Guard assumed responsibility. Sherwood Point was staffed by Coast Guard personnel until 1983, when it was finally automated. It holds the distinction of being the last manned lighthouse on the Great Lakes. Today, the light is still in service, and the Coast Guard uses the keeper's quarters as a retreat or vacation cottage for its servicemen and their families. As such, the light and its grounds are not open to the public.

For nearly two hundred years, the lighthouses of Door County have perched as sentinels along the shore, guiding mariners to the sheltering harbors and bays. Lighthouse keepers performed a job that was difficult, lonely and sometimes deadly, but the lives they saved and the tragedies they prevented surely have earned them a special place in the hearts of all. Today the automated lights man the coastline, and radar replaces common sense, but the bravery of those who dedicated their lives in the service of others should not be forgotten.

Part II

The Bay Side
and Beyond

STURGEON BAY AND SOUTHERN DOOR

The bay was literally alive with large fish called sturgeon...Farmers
around the area would come to Sturgeon Bay at spawning time and pick up
wagon loads [of the fish] *for fertilizer.*
—Carl Raymond Christianson, author and shipbuilder

The city of Sturgeon Bay is located on the Door Peninsula, about forty miles north-northeast of the city of Green Bay. The actual bay is a natural arm of Green Bay, and it extends about eight miles across the land toward the Lake Michigan shore to the east. What began as a sleepy little lumbering settlement soon grew into a vibrant city and the county seat of Door County. It is also informally recognized as the line of demarcation between the quiet farmland communities of southern Door and the rugged fishing and lumbering (and now tourist) towns of northern Door.

In fact, when most vacationers speak of Door County, they are referring to northern Door. The towns of southern Door certainly have much of the charm and history of their northern kin, but they never gained quite the same traction with tourists and travel writers. Even in days of old, immigrants who settled in the rolling fields at the base of the peninsula were more interested in fertile farmland and agrarian pursuits than in the rocky and forested north woods. Their stories were of quiet labor and faith, not of colorful explorations. The towns and villages of southern Door are part of the largest Belgian-American settlement in the United States and still display numerous signs of their heritage, although most of the original buildings were wiped out in the deadly Peshtigo firestorm of October 1871.

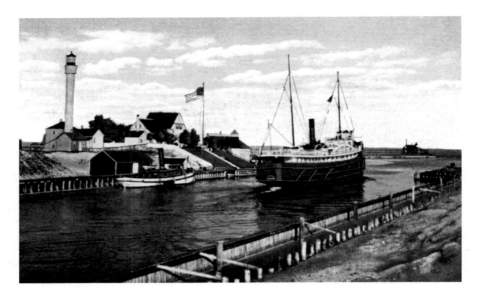

The opening of the Sturgeon Bay Ship Canal cut more than two hundred miles off a typical round trip from Milwaukee or Chicago to Green Bay.

After the fire, many of the residents rebuilt their homesteads in red brick, reminiscent of the stone houses of the Belgian tradition. Roadside chapels, a testament to their predominantly Catholic faith, dotted the landscape as they did in the old country. And an unfamiliar language peppered the conversations at cattle auctions and grain elevators. Most of the Belgians in Door County trace their roots back to southern Belgium, near the French border, where they spoke the regional French dialect of Walloon. Walloon is considered a dying language, and after it was replaced by standard French in Belgian schools (and unfairly denigrated as coarse and illiterate after World War I), most generational transfer ceased. There are many who disagree, however, and are working to keep the distinctive and beautiful language alive. Besides Belgium, Door County is one of the few areas in the world where native speakers of Walloon still exist.

Other nationalities that settled in the area in large numbers were Moravians, Scandinavians, Germans and Poles. Many of these immigrants came here to escape the famine and disease outbreaks rampant in Europe during the nineteenth century. The vast unexplored lands of America promised a better life to those who could travel here and claim a part of it, and each group brought its own traditions and beliefs to the new land. Door County is not so much a melting pot but rather of a colorful mosaic of European and indigenous cultures.

Workers at an early shipbuilding plant in Sturgeon Bay.

The first white settlers who moved to Sturgeon Bay arrived about 1835 and ran small lumber trades. At the time, the little settlement didn't seem to have a lot going for it; better farmlands stretched to the south, and better lumbering opportunities spread to the north. The bay itself was mostly swampy marshland, and the sturgeon that occupied the waters were considered more suitable as fertilizer than food. The giant bony fish can weigh more than 150 pounds, but they are bottom feeders and weren't quite as desirable as the delectable trout, salmon, whitefish and walleye that flourished in the waters of Lake Michigan and Green Bay. It wasn't until the 1870s, when Joseph Harris Sr., the editor of the *Door County Advocate*, began to champion a new ship canal that the town realized its full potential.

Harris realized that ships traveling between Green Bay and Lake Michigan faced a long and dangerous voyage around the peninsula and through the Porte des Mortes passage. By cutting a navigable canal through Sturgeon Bay, the journey would be reduced by nearly two hundred miles and ships could avoid the deadly northern straits. Native Americans had long used the short portage between Sturgeon Bay and Lake Michigan, but the bay wasn't deep enough for large commercial vessels. It wouldn't take a lot of money or effort, however, to dredge a deeper channel in the bay and excavate the remaining sliver of land, effectively turning northern Door into an island.

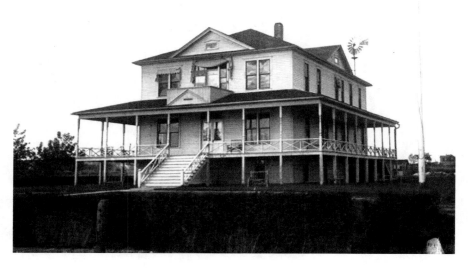

The first hospital in the area was located in Sturgeon Bay. Many towns did not even have a doctor in residence.

In fact, some geologists believe that northern Door was indeed a type of presque-isle, connected to the mainland only by a long-term accumulation of silt and wave-tossed rocks.

Harris and his supporters went before Congress to request the land and funding necessary for the project. In a sixteen-point proposal, the group compared the one-time cost of building a canal, a breakwater and a new harbor ($500,000) to the yearly average cost of ship losses in Death's Door (estimated at a conservative $75,000 per year). In one of the final points, the supporters summed it up: "It is an important public work, involving but a small grant of the public lands to consummate a great public improvement, which, when completed, will be hailed with joy and satisfaction, not only by the great lumber interests of Green Bay, but by thousands of shippers, captains, seamen, and ship owners of the Upper Lakes." Congress agreed, and work started on the new canal in 1872. A private group headed by William Ogden, president of the Chicago and North Western Railway, began excavating the 1.3-mile-long section of land that divided Lake Michigan and the bay. By 1880, it was navigable by small vessels, but the final dredging and deepening that would allow large ship traffic wasn't completed until 1890.

Once the canal was complete, northern Door's tenuous land connection to its southern half was completely severed. The only way to reach the north was

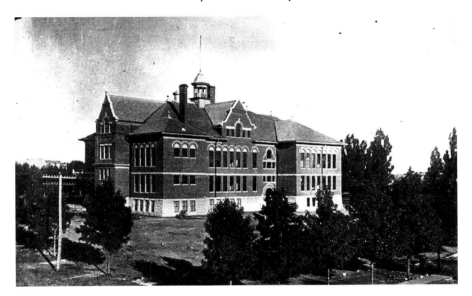

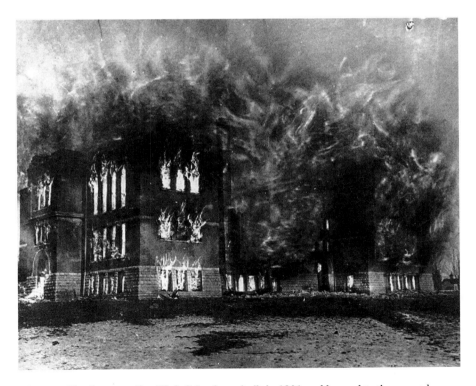

This page: The Sturgeon Bay High School was built in 1901 and burned to the ground in 1908. There were no casualties, but it was a financial disaster for the town because insurance only covered about half of the loss.

by boat. In 1886, a private company headed by John Leathem, Tom Smith and Rufus Kellogg seized the opportunity and built a wooden swing toll bridge across the canal. Tokens for the bridge were sold at five cents for pedestrians and twenty-five cents for horses and wagons. Actually, that was a rather princely sum in those days, and the Sturgeon Bay Bridge Company made a handsome profit. In 1894, it reinforced the bridge so that it could carry the weight of railroad cars, and the Ahnapee & Western line began a passenger service from Algoma to Sturgeon Bay. In 1911, the private charter ran out, and ownership of the toll bridge reverted to the city. The city maintained the bridge until 1931, when a new highway bridge at Michigan Street made the old toll bridge obsolete. The City of Sturgeon Bay sold it to the railroad for one dollar, and Ahnapee & Western operated it until 1966, when it sold it back to the city, also for one dollar. In 1968, the deteriorating bridge was abandoned, and the railroad canceled its Sturgeon Bay service. Finally, in 1973, the old truss bridge and remaining trestle, serious hazards to navigation, were removed.

Today, the canal is maintained by the U.S. Army Corps of Engineers and is heavily used by both commercial and pleasure craft. Three bridges provide easy access across the bay: the 1931 Michigan Street Bridge, which was recently listed in the National Register of Historic Places; the 1978 Bay View Bridge; and the newly added Maple-Oregon Bridge, which was opened to traffic in 2008. Mr. Harris was definitely a visionary when he proposed the great canal, for it has helped shape the growing city throughout its history. Now, barges filled with goods traverse Sturgeon Bay with ease, leaving the straits of Death's Door to fishermen, sailors and tourists who are attracted to its fierce beauty. That's not to say that the waters around the bay are harmless; shipwrecks litter these waters as well, although many here were lost to fire and abandonment and not quite as frequently to the deadly storms that roar up and down the coast.

In fact, although some ships came to Sturgeon Bay to die, many more were born here. A proud tradition of shipbuilding lives on in the town from its earliest roots in the early 1800s. At that time, lumbering and fishing were the two main industries on the peninsula, and both required boats. The need for fishing boats is obvious, but lumber tradesmen required boats to transport their goods to other ports. The closest big shipbuilding towns on the Great Lakes were mostly in Michigan, which required a buyer to make a long journey there to make a purchase and another long and dangerous journey back through Death's Door to return to Green Bay.

Although some craftsmen began building their own small boats, and perhaps even selling their skills to neighbors, it wasn't until 1855 that the

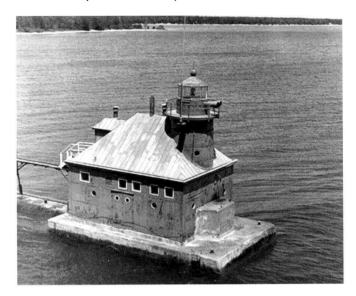

The Sturgeon Bay Ship Canal Pierhead Light was originally built in 1882. Later, fog sirens were added, and the structure was completely renovated in 1903 to incorporate light and sirens into one building, as seen in the photo.

Laurie brothers opened a small shipbuilding business at the mouth of the bay. Using local timber, the brothers constructed a fleet of fine schooners, including the *Belle Laurie* and *Kittie Laurie*. *Belle Laurie* was abandoned by the mouth of the Fox River in 1894, and *Kittie Laurie* was stranded in a storm near Ephraim in 1889. Like other pioneers of the day, the Laurie brothers were quick to exploit all that the land had to offer, and in 1880, they opened the Laurie Stone Company to sell the limestone they quarried from their property. Some of the Laurie ships were turned into stone barges, and the brothers built small wooden steam tugs to pull the barges to market.

Soon, others followed, and by the end of the century Sturgeon Bay's reputation as a shipbuilding center was solid. John Leathem and Tom Smith, who had built the wooden toll bridge in town, also entered the shipbuilding trade. Leathem and Smith were entrepreneurs of the highest order. They first came to the area as lumbermen and then opened a sawmill when they realized that they could expand their profits. Eventually, the partners decided to expand once again and opened the Leathem and Smith Towing and Wrecking Company with the intention of towing lumber barges to market. As that business grew, they began to build barges and tugs. In 1893, they also opened a dolomite quarry at the mouth of the bay, specializing in crushed gravel for railroad beds and roads. With their own fleet of tugs and barges, their business grew into one of the most substantial in the area.

Unfortunately, John Leathem's health began to fail, and he moved to San Diego, where he died in 1905. Tom Smith's son, whom he had named Leathem after his lifelong friend and business partner, joined his father in the businesses. Some of the early histories of the area stumble at the distinction between the early Leathem and Smith companies run by John and Tom and the latter Leathem D. Smith companies, run by Tom Smith's son. In any case, the Smith family continued to be very successful. During World War I, the younger Smith had rejuvenated his father's early barge building business by winning a contract to build nine one-hundred-foot wooden harbor tugs for the United States Shipping Board. He expanded and modernized the quarry, building it into one of the area's largest and most technically advanced stone producers. Smith also patented a new and more efficient method for self-unloading lake ships, using a system of dragline scrapers rather than the conventional and unwieldy belt conveyors in use at the time.

By World War II, the demand for military vessels created a boom in the shipbuilding business in Sturgeon Bay. Four major shipyards employing a total workforce of eight thousand worked around the clock,

The Michigan Street Bridge in Sturgeon Bay is listed on the National Register of Historic Places.

launching new ships at a rate of one every five days. The Leathem D. Smith Shipbuilding Company churned out sub chasers, patrol frigates, cargo ships, water tankers, tenders and tugs for the U.S. Navy and the U.S. Maritime Commission. The neighboring Sturgeon Bay Shipbuilding Company supplied many U.S. Army ships, including box boats, freighters, tugs and towing and retrieving vessels. Sturgeon Bay Boat Works built air-sea rescue boats and freighters, and Peterson Boat Works supplied army aircraft rescue boats and navy sub chasers. Other Wisconsin shipyards were just as busy. Down the Lake Michigan coast, the Manitowoc Shipbuilding Company employed nearly seven thousand men and women and supplied a steady stream of navy submarines.

Once the war ended, the boom slowed, but the demand for pleasure and commercial craft did not fade away. Sturgeon Bay Boat Works is today known as Palmer Johnson, a builder of high-performance luxury yachts. Peterson Boat Works, unfortunately, ceased operations in 1995, and some of its old buildings are being restored into residential condominiums. Leathem D. Smith Shipbuilding was sold to its management and renamed Christy

Old tugboats docked at Door County Maritime Museum in Sturgeon Bay. The historic Michigan Street Bridge is in the background. *Photo by Peter Rimsa.*

The navy sub chaser USS *PC-589* was built by the Leathem D. Smith Shipbuilding Company in 1942. It was decommissioned in 1946 and eventually sold for scrap in 1959.

Corporation after Smith's accidental death by drowning in 1948. In 1967, Manitowoc Ship Building Company closed its facility and acquired Christy and the adjacent yard, Sturgeon Bay Shipbuilding, and named the new combined company Bay Shipbuilding Company. In January 2009, Bay was sold to an Italian shipbuilder, Fincantieri, which builds both merchant and naval ships, especially large luxury cruise ships for companies such as Disney, Princess, Holland America and Carnival Cruise Lines, and promised to bring new business to the area. It appears to be true, because Bay recently announced that it has received a contract to build two platform supply vessels for use in marine support services for the offshore energy industry. It's an exciting new development, one that promises to keep the shipbuilding business strong.

It has seen many changes over the years, but Sturgeon Bay remains a city forever united with ships and the Great Lakes on which they sail. It is home of the Door County Maritime Museum, and vessels of every type and description pass through its canal or dock in its harbors. Although many tourists see it as the final series of stoplights before they reach the "real" Door County, it has plenty to offer to those who choose to linger along its shores and soak up its rich heritage.

SISTER BAY

Come to Sister Bay to unplug, take your chances with Mother Nature's whims to play outside, and then relax inside. Then do it all over again.
—Sister Bay Tourism

Sister Bay earned its name from the two islands that stand shoulder to shoulder off its coast, like twin spinsters peering across the waves. Old-time sailors noticed that the islands looked nearly identical from the water and began calling them "the Sisters." Soon the name stuck, and settlers called the L-shaped bay behind them Sister Bay. Although newcomers often pronounce it as "Sister's Bay," there is no possessive "s" at the end. Like everything else on this land that was forged through hard work and simple values, there is no need for the extraneous or superfluous.

The early settlers came from Scandinavia and carried the strong work ethic and respect for nature from their home countries. In 1857, Ingebret Torgeson was the first to settle permanently in Sister Bay and was later deeply involved in the process that created the township of Liberty Grove. John Thoreson followed and built a dock, a general store and a blacksmith shop to the south, in an area known as Little Sister Bay. In 1865, brothers Andrew and August Seaquist constructed a large sawmill in town. Soon, others followed, and the twin settlements of Little Sister Bay and Big Sister Bay flourished as both lumbering and farm towns. When Liberty Grove was incorporated in 1859, the unincorporated towns fell under its jurisdiction.

By 1870, the area had become an important shipping point for lumber and grain bound south for Green Bay or north to Michigan. A company named Henderson, Coon and Dimond quickly built a commercial pier at

DOOR COUNTY Vacation Paradise

SCENERY

250 miles of lovely shoreline . . . picturesque villages, old world charm, cliffs of limestone, gently sloping sand dunes, clean sand beaches that stretch for miles combine to make Door County Peninsula an exciting, wonderful vacation paradise.

FISHING

The waters of Door County are rich-in-catches of small-mouthed Black Bass, Jumbo Yellow Perch and Great Northern Pike. Enjoy one of the many delicious "Fish Boils" . . . an old Peninsula custom where fish are boiled in large kettles with potatoes and lots of salt. Truly a gourmet treat!
LATE APRIL to MID-MAY — Jumbo Perch run
JUNE — best Walleye fishing
JUNE, JULY, AUGUST, SEPTEMBER — excellent Bass fishing

BOATING

Fine harbors and marinas located on the Peninsula can service anything from putt-putts to the largest cruising and sail boats. You'll thrill to delightful shoreline vistas and beautiful islands as you cruise Sturgeon Bay, Green Bay or Lake Michigan.

GOLFING

Four courses at your disposal! Beginner or pro, you'll enjoy some of the most spectacular scenery seen anywhere, while improving your game.

WATER SPORTS

Water Skiing is fun as you ski in and out of coves and bays past majestic awe-inspiring cliffs bordering the Peninsula shoreline. Some of the best skin diving in the Mid-West is here —explore over 100 sunken vessels. There are three air stations for filling tanks located in the county.

YEAR 'ROUND SPORTS

Door County has fine ski-trails, excellent ice skating and the ice fishing is superb too! Tobogganing is popular on the many lovely hills throughout the county.

ACCOMMODATIONS

Unsurpassed vacation facilities, spacious resort hotels, excellent lodges, modern motels and cottages with every convenience. Camping grounds available . . . in fact everything to meet your whims and desire for the VACATION OF A LIFETIME.

RATES

Today, Door County is still unspoiled — not over commercialized. No inflated mid-season rate schedules prevail. Over 20,000 residents are anxious to help you enjoy a never-to-be-forgotten vacation.

An early tourist brochure rhapsodizes about Door County's many charms.

the head of the bay to accommodate larger ships, which Thomas Dimond managed. A few years later, it was sold to a Belgian immigrant by the name of Andrew Roeser, and soon "Roeser's Pier" was typically abuzz with activity as schooners and lake steamers pulled in and out of the dock all day, disgorging supplies for the boomtown or loading new outbound freight. Andrew and his son, August, added a large gristmill and storage buildings, as well as another sawmill. In order to accommodate all of the travelers, the Dimond family built the Sister Bay Hotel near the dock.

The Bay Side and Beyond

Next came the inevitable saloons, trailed closely by the churches that preached against the dangers of alcohol. Zion Lutheran was the first, with Baptist and Catholic congregations not far behind. Shortly after the turn of the century, St. Rosalia's Catholic Church constructed a beautiful chapel right at the intersection of two main roads leading into town, now State Highways 42 and 57. The congregation remained at that spot until 1984, when they built a larger church slightly to the south. The old chapel was redeveloped into a fine restaurant named the Mission Grille, which duplicated many of the elements and the ambiance, including stained-glass windows and wooden pews culled from a church in Park Forest, Illinois. The restaurant is a popular venue to this day. In an ironic twist, the original altar area now houses the bar.

In April 1912, flushed with success and aching for structure, a handful of the most prominent citizens filed the necessary papers to incorporate the town of Sister Bay as an entity independent from Liberty Grove. The new town merged both Little Sister Bay and Big Sister Bay into one municipality, although it's not uncommon to hear old-timers still refer to "Little Sister" as a separate area. If the denizens of the newly formed metropolis believed that 1912 would be their banner year, however, they were sadly mistaken.

That spring and summer, a severe drought struck the area. Crops grew sparsely, and the farmers struggled to coax subsistence from the nearly barren land. Just as a few tender plants managed to wriggle free of the dry earth, a terrible hailstorm struck and flattened them in rows. The tenacious and determined immigrants soldiered on, trying to recoup some little harvest, but to their horror Mother Nature was not yet done toying with them. On the heels of the drought and hailstorm, a plague of grasshoppers converged on the already weakened fields, destroying what few plants had survived. The prospect of a cold and hungry winter loomed ahead. Just when it seemed that things couldn't possibly get any worse, they did.

The drought had left the area bone dry, and a stray ember, whipped by winds off the lake, created a conflagration that roared through the central business district. There was no local firefighting brigade at the time, but residents responded en masse to an alarm bell that a bystander clanged furiously. They quickly formed a bucket brigade from the waterfront to the row of wooden stores that were rapidly being consumed by flames and did their best to douse the fire. By the time the blaze was under control, most of the structures on the main street had been destroyed. Three stores, a hotel and two houses had burned down completely, and others were damaged. The pioneer spirit remained strong, however, and the people simply cleaned

A herd of goats dwell on the rooftop at Al Johnson's landmark restaurant in Sister Bay. The log exterior of the building was crafted in Norway, shipped to Door County and placed around the original building.

up and rebuilt even bigger and better, as one did in those days. The next year, fate was kinder, and the town resumed its path to growth and stability.

By the early 1900s, the area was slowly transitioning from lumbering to farming and from shipping to tourism. New hotels and resorts were opened, and towns across the peninsula began to advertise and compete for vacationers. Postcards were extremely common and displayed everything from lodging and attractions to local disasters. In many cases, these early picture postcards have served to document history more thoroughly than newspapers of the time, which were mostly text and often inaccurate, given to wild boasts and shameless hyperbole. Sister Bay was no exception. Postcards and brochures advertised the village's pleasant beaches, luxurious hotels and fantastic dining. It wasn't unusual for the area's population to triple or even quadruple over the summer as guests from around the Midwest descended like the horde of hungry grasshoppers. Most of the businesses had to add extra staff during the summer months and sometimes called on relatives and friends back in the old country to come and assist. Today, foreign exchange students flood the area for summer work, lending a delightful diversity to the accents heard around the villages and towns of the Door.

One of Sister Bay's oldest and most iconic eateries is Al Johnson's Swedish Restaurant. Johnson's began in the early 1950s as a simple one-

man café, serving breakfast, dinner and sometimes lunch, provided that Al wasn't out fishing in the afternoon. The food was good, the coffee was hot and the fellowship was pleasant. In 1960, Al met Ingert, who would soon become Mrs. Johnson. Ingert had a more focused vision for an authentic Swedish restaurant and gift shop, or "butik." In 1973, the Johnsons decided to renovate. Using careful measurements from the restaurant, Al and Ingert ordered log buildings from Norway that were designed to assemble around the existing structure. In true Scandinavian style, they added a special underlayment for the roof and covered it with sod. It was common in Norway to see sod-roofed homes built into the side of hills, with sheep and goats grazing lazily atop. Al had no intention of carrying the tradition to that extreme, but one of his dear friends, Winky Larson, had a different idea. With a goat named Oscar tucked under his arm, Larson climbed a ladder and headed for the roof.

As the story goes, the first attempt was unsuccessful. Oscar apparently wasn't a Norwegian goat and had no intention of roosting on a rooftop. His struggling knocked over the ladder and landed both him and Larson on the ground. The goat was fine, albeit annoyed, but Larson suffered a broken collarbone in the fracas. A later second attempt succeeded without any bloodshed or broken bones, and Oscar decided that his new vantage point

Even today, remnants of Door County's past can be found at every turn. *Photo by Peter Rimsa.*

from the rooftop was pretty cool after all. Al added a few more goats and built a gated wooden ramp at the rear of the building so that the animals could climb up and down without the need for an assistant with a ladder. Today, the goat herd "works" about eight hours a day, May through October. As evening approaches, they scramble down their ramp and head back to the farm, tired from an exhausting day of being adorable. They're not allowed on the roof during cold or stormy weather and are obviously quite tame and pampered. They gaze at the throngs below with an air of bored indifference usually perfected only by movie stars tiring of the paparazzi, while children screech and adults snap photos.

What began as a joke has turned into a major marketing coup for the restaurant. Locals from towns all over the county are used to giving directions when tourists ask about "that goats-on-the-roof place." In fact, the association between goats and the restaurant is so strong that the Johnson family recently sued a Georgia market that had goats on their roof under the contention that it constituted a form of trademark infringement. The market owner declined to enter into a costly lawsuit and instead agreed to pay the Johnsons a type of licensing fee for the right to let goats graze. Another, more local, squabble occurred when a gift shop on Washington Island allowed goats onto its thatched roof. The gift shop, like the Georgia market, was loath to incur legal fees and simply removed the animals. The Johnsons know how important the goats are to their business and have even coined a marketing phrase: "Come for the goats, stay for the food."

Al Johnson's, although perhaps the most famous, is by no means the only merchant in Sister Bay that displays its Nordic heritage. Many of the stores in town specialize in merchandise from Norway, Finland, Denmark, Sweden and Iceland. Scandinavian flags flap in the breeze alongside the Stars and Stripes. It's as easy to find gravlax, torskeboller and fiskepudding as it is to find pizza and burgers. The Sister Bay Historical Society has restored one of the oldest remaining homes in town, Alex and Emma Anderson's 1875 farmhouse, into a fascinating museum that celebrates the culture of its founders. The society also purchased more than six acres of land to the north in order to create a farm museum. Aptly named Corner of the Past, the acreage now contains a granary, a migrant worker's cottage, a post-and-beam barn, a machine shed, a sawmill, a blacksmith shed, log cabins and a chicken coop. The buildings are authentic—many more than one hundred years old—and have each been donated and moved from surrounding farms.

Today, Sister Bay is known more for its fine dining, trendy shops and modern marina than for its past as a farming and trading community. Thanks

Aqualand on Highway 42 was a small roadside zoo and petting farm that drew crowds of tourists and locals alike during the summer.

to the hard work of dedicated preservationists and historians, however, it's possible to look back fondly at a bygone era, when life was much harder but likely just as satisfying. Visitors will come away with a greater understanding of the challenges that faced the early settlers. And most likely, they'll also come away with a picture of a goat.

FISH CREEK AND
PENINSULA STATE PARK

The Doctor presided over his exclusive realm with great pride and a firm hand. An early guest once saw his portly, bearded figure standing on the porch of the Casino, gazing over his resort, and announcing "Das ist alles mein!" (This is all mine!)
—*Fish Creek historian Ann Thorp*

In 1844, Increase Claflin, the peninsula's first white settler, moved his family from Little Sturgeon Bay to a new homestead on land that is now part of Peninsula State Park. He was soon joined by Asa Thorp, a cooper from the East. Although Claflin preceded Thorp, it was Thorp who dreamed of turning the quiet cove into a grand settlement. Like many of the other Door County towns, Fish Creek's earliest pioneers were fishermen and loggers. Thorp's first goal was to build a pier, a basic necessity for any settlement hoping to attract trade. Once that was accomplished, he promoted his skill as a cooper; building fish barrels was labor-intensive, and a talented barrel maker could make quite an attractive living in a busy fishing port. Thorp was industrious and soon had the means to build a grand inn for tourists. It was named, aptly enough, the Thorp Hotel.

Each week during the summer, ships from the Goodrich Steam Line puffed up to the dock carrying a new load of vacationers from places around the Great Lakes and beyond. The *Georgia*, the *Alabama* and the *Carolina* each arrived in turn, filled with jubilant refugees from the heat-soaked cities. The moderating effects of the surrounding waters and the cool, dark forests always kept the temperature a solid ten degrees lower than cities on the same latitude, and the fresh lake breezes cast away any trace of urban grime. Giddy

Eagle Tower in Peninsula State Park sits atop a tall bluff, allowing visitors to see all the way to Upper Michigan when visibility is good.

with relief and awed by the natural beauty of the area, the travelers would tumble out onto the pier, anxious to spend every single moment soaking up the local ambiance. The lake steamers were really the only way to access the peninsula; there was an overland route that ran from Sturgeon Bay, but few tourists wished to tolerate a long and tedious stagecoach ride over rutted and dusty trails. Besides, it was equally as difficult to access Sturgeon Bay in the years before cars and highways. The steamboats provided a degree of comfort and refinement, and travelers could enjoy a meal or nap in a private berth during the trip, making the ride itself a pleasant diversion instead of a necessary evil.

In 1896, a well-to-do family from Milwaukee stepped off a steamer onto the Fish Creek dock. Dr. Herman Welcker and his wife, Henriette, and daughter, Mathilda, arrived for a summer stay and were immediately enchanted. Welcker was a German-born physician and virologist who had immigrated with his family to Wisconsin just two years earlier. He was apparently doing quite well in his adopted city, but after a brief period in Fish Creek, he decided to give it all up and move to the peninsula. Perhaps the forested terrain reminded him of his country of birth, or perhaps he simply wanted to exploit a potential financial bonanza. In any case, Welcker decided

to enter the rapidly growing tourist trade and came up with a plan to create a European-style wellness spa. He bought a parcel of land from Asa Thorp that was just a short distance from the water, and there he built a charming little hotel, naming it The Henriette after his wife. He quickly purchased more land and surrounded The Henriette with small white cottages. Still not quite satisfied with his empire, he acquired the Lumberman's Hotel on the opposite side of Green Bay in Marinette, Wisconsin. When winter came, he had the building partly disassembled and dragged eighteen miles across the frozen surface of the bay, all the way from Marinette to Fish Creek.

He placed the new building across the road and slightly east from The Henriette and named the complex Welcker's Casino. Inside, the basement was furnished with billiards, gaming tables and card games for men, along with an icebox filled with beer and other beverages. Upstairs, the fairer sex could amuse themselves with mahjong, ping pong or bridge. The casino also featured a pleasant sewing room for the ladies and small games for children. It was the undisputed social hub of Welcker's grand resort, and visitors might be treated to concerts, plays and art exhibits in its grand hall. Whatever amusements the guests were enjoying, however, came to a screeching halt before 10:00 p.m., which was the nonnegotiable "lights out" hour. It was,

No trip to Door County is complete without joining in the fun and feast of a traditional fish boil.

after all, a health resort, and the good doctor expected his subjects to be well rested for the next day's regimented plan of hiking, swimming and a two-hour silent period of meditation. Lodgers were obligated to comply; Welcker would tolerate no disobedience or discussion. He attempted to fill the resort with the sophisticated and moneyed, but his standards were strict. One legend has it that he refused lodging to an heir of the wealthy Pabst Brewing Company because he didn't like the young man's attitude or style of dress.

Although Welcker had ceased practicing medicine when he moved to Fish Creek, he would sometimes offer medical advice or assistance when needed. At one point, an outbreak of deadly smallpox virus threatened the region. As a trained virologist, he was aware of the success that English scientist Edward Jenner had experienced nearly one hundred years earlier when searching for a cure for smallpox. Jenner had discovered that milkmaids and farmworkers exposed to the common and nonlethal cowpox virus developed immunity to smallpox, and he used that knowledge to create the world's first true vaccine. Welcker understood the process but didn't have access to cowpox or the cattle needed to grow the vaccine.

In a brazen shortcut, the doctor used one of Asa Thorp's children, eleven-year-old Merle, as a reservoir. He inoculated the boy repeatedly with a weak and controlled dose of smallpox in a risky process known as variolation. This method, if performed successfully, creates only a mild illness but provokes a strong immune response. If not successful, however, the patient can contract a full-blown case of the disease and die or at best never develop a sufficient immune response to prevent later infection. Welcker was lucky (and so was Merle); the rather crude plan worked. Once it was clear that Merle's immune system was doing its job, Welcker drew his blood and injected it into other children to transfer the antibodies. Fish Creek was spared an epidemic.

Henriette died in 1920, and the doctor followed just four years later. Welcker's niece, Martha Fahr, continued to run the resort until her death in 1939, at which point the buildings were sold off individually. The Henriette lodge changed hands and names several times over the years, until it was restored and renamed the White Gull Inn in 1959, the name it retains to this day. The current owners, Jan and Andy Coulson, purchased the property in 1972 and have made numerous improvements. Although they've updated things such as plumbing and electricity, they've meticulously maintained the Old World feel. Rooms are decorated with antiques, and the massive two-sided stone fireplace between the lobby and dining rooms still burns wood. The Coulsons also purchased Welcker's old casino building and turned it

DOOR COUNTY

in The Wintertime!

Of what do you think? Of subzero weather? Impassable roads? A deserted Peninsula?

Not so! The average temperature from December thru March is 24 degrees. Broad highways are open all months of the year, keeping the Peninsula accessible. As for being deserted, you should enjoy a scene such as Robert Frost's apt words describe:

> ". . . the cottages in a row,
> Up to their shining eyes in snow."

You should experience pleasant hospitality beside crackling fires where inns are ready with their usual welcome — the same welcome that greets you in the summertime.

* * * * *

Door County in the Wintertime! The crunch of feet on crusty ground . . . warmth of the sun overhead . . . young birches against a scarlet sky . . . sturdy evergreens with branches outstretched like children's fingers testing a sugar frosting . . . cherry orchards casting charcoal patterns in the twilight.

Bold outlines of the maples shorn of their fluttery leaves . . . an eagle's nest you couldn't locate in July, hidden in the tree-top . . . the charm of a red barn in the distance . . . Swedish pancakes with lingonberries.

Winter in northern Wisconsin offers delights undiscovered in other seasons, tempting as they are. The ice-blue of the bay, holding its turbulence in check until spring . . . craggy bluffs blanketed in white . . . and the slopes. *It's the slopes we want most to talk about.*

For, this year we have a ski area (with five runs and lifts) on U.S. Highway 42, approaching Fish Creek. It can be reached by train and bus, car, and plane. The airports at Sturgeon Bay and Ephraim will be open, and skiers will be met by station wagon at either field.

Long famous as a summer resort, Door County makes its bow as a ski resort this winter of '61 and '62. We think we have the finest ski area in Wisconsin. Come up and pay us a visit!

. . . *Ruth MacKay*

DOOR COUNTY
Winter Playground
NOR-SKI RIDGE

Information:
Nor-Ski Ridge
Box 11, Sister Bay

Snow Reports

Phone:
Mgr., Sister Bay	4411
Ski Area Fish Creek	42413
Chicago	DE 2-7144

A 1961 advertisement for Door County's only downhill ski area extols the virtues of winter tourism.

into the charming Whistling Swan Inn, which they sold in 1996 so that they could focus on the White Gull.

Rocky Fairchild, a lifelong Door County resident, recalled the early days of the glamorous inns, back before electric refrigeration was commonly available. At that time, ice cutters would go out onto the bay with horse teams, saws and picks and harvest huge slabs of ice—often weighing more than one hundred pounds apiece—and carry them by sled back to shoreline

icehouses. There, the ice would be placed on a bed of sawdust, with another layer of sawdust over each successive slab. In this manner, the ice would last most—if not all—of the way until the next winter. Over the summer, ice delivery men carried the slabs on horse-drawn wagons to each customer's home or business, where they would hammer off a chunk of the proper size to suit the customer's need.

When Rocky's father was a young teenager, he and his friends were able to earn extra cash by sweeping and cleaning the icehouses on Fish Creek's shoreline in preparation for the new winter's ice harvest. One year, the youths found several bottles of what appeared to be homemade soda pop laying amid the damp sawdust and dwindling bits of ice. Thirsty, they popped open a bottle and took a taste. It was quite good, they thought, and they opened yet another. Only after they had finished off the last bottle and had difficulty standing up did they realize that the "soda pop" was actually wine set out to chill from the nearby inn.

One of the most popular attractions at the White Gull Inn is the traditional fish boil, an iconic feast that can be found at restaurants all over Door County but apparently nowhere else in the civilized world. The fish boil is as simple as it is delicious and probably began on the fishing boats that plied these shores. Each chef, however, claims his own secret method, and the flamboyant preparation is as much a part of the tradition as the food itself. It begins outdoors, with a large cast-iron or stainless steel kettle of water, heated to boiling over an open wood fire. The cook tosses in whole red potatoes, salt, fresh whitefish (or possibly lake trout, for the nontraditionalist) and sometimes corn on the cob or onions. After a proper period of boiling, the fish oils rise to the surface. At just the precise moment, the boil-master tosses a small amount of kerosene onto the burning logs, which explodes into a small fireball. The sudden increase in temperature causes the pot to boil over, and the cascading water extinguishes the flames. Dinner is now ready. The fish and potatoes are typically served with coleslaw and rye bread, with a generous slice of Door County cherry pie for dessert.

Down the street from the White Gull and the Whistling Swan is the 1875 farmhouse of one of the other early residents, Alexander Noble, who was born in Edinburgh, Scotland, and was a blacksmith by trade. He was one of the original town founders, along with Asa Thorp, and served as the postmaster and town chairman at various times. His white Greek Revival–style home has been completely restored by the Gibraltar Historical Association and still contains many of its original furnishings and artifacts. And just beyond is the 1875 Vorous General Store, an Italianate-style edifice

A map of the Nor-Ski trails between Egg Harbor and Fish Creek. The location now houses a resort, but the ski trails are long gone.

that today houses a women's clothing and accessory shop. Both buildings are listed on the National Register of Historic Places. In fact, so many historical buildings still exist in Fish Creek that it's easy to imagine what the village looked like back when Dr. Welcker marched his guests in a brisk morning hike through the dirt streets and along the rocky beach. Even a small log cabin once belonging to Asa Thorp survived the centuries and now sits in a place of honor in the town center known as Founder's Square.

On the eastern edge of Fish Creek lies the entrance to Peninsula State Park, the third-largest state park in Wisconsin and definitely the best equipped. It was founded in 1909 with land purchased at about twenty dollars per acre and now covers 3,776 acres of dolomite bluffs, deep forests, peaceful meadows and quiet coves along eight miles of Green Bay shoreline. It is the location of Eagle Bluff Lighthouse and Eagle Tower, a seventy-six-foot-tall observation tower situated on a nearly two-hundred-foot-high bluff. Anyone brave enough to climb to the top of the swaying, open wooden structure perched at the edge of the sheer cliff will be rewarded with a breathtaking view of nearby islands and the distant shore of Michigan. Eagle Tower is one of two originally built in the park in 1914; one on nearby Sven's Bluff was dismantled in 1947 due to wood rot, and it was never replaced. The current tower was rebuilt in 1932 and has stood as a sentinel of the bay ever since.

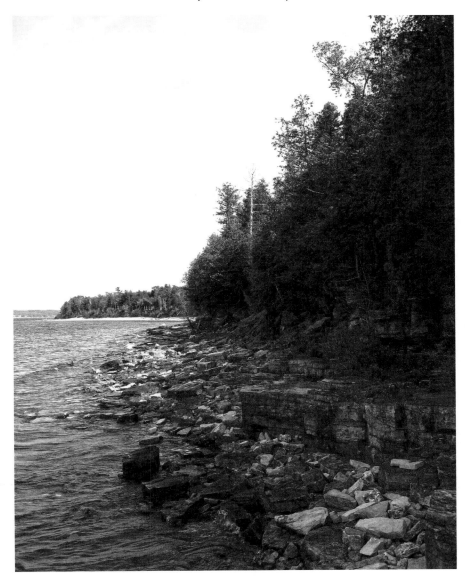

The Niagara escarpment is easy to see in many areas along the coast, such as this spot in Fish Creek. *Photo by Peter Rimsa.*

The park also includes a nature center, a theater troupe, an eighteen-hole golf course and driving range, biking, hiking, ski trails and nearly five hundred campsites, many with electricity. Despite the human presence, the heavily wooded bluffs and central meadows contain a variety of wildlife.

Deer are plentiful, and the wide variety of different habitats in the park attracts birds of every type. Herons and cranes wade in the shallows, searching for minnows. The inland high meadows are rife with songbirds, pileated woodpeckers, ruffled grouse and wild turkeys, while ravens and eagles nest along the rocky cliffs. Each season bestows its own special beauty. During spring and summer, the land is bursting with life, and wildflowers scatter touches of color among the cool forest greens; autumn brings rich hues of gold, red, yellow and bronze to stand in bright contrast to the white birches and deep-green cedar and pine. And in winter, the sun sparkles off the impossibly white snow, while chickadees and northern cardinals hop among the evergreens, chattering loudly at any visitor who dares to intrude on their land.

Although these grounds have been a protected park for more than one hundred years, there are still plenty of signs of the settlers who once lived in these woods. The meadows are actually the remains of small, cleared farm plots. In the center of the park, on Mengelberg Lane, is the Blossomburg Cemetery, established in 1904. Burials are still performed at this public cemetery, but many of the graves are quite old, hinting at life at the turn of the century. Many graves hold children who succumbed to now common childhood illnesses such as measles and mumps. The names are often familiar to historians and clearly show the German and Scandinavian heritage of the area. Another small private burial ground in the park, known as Pioneer Cemetery, holds the graves of town founders Asa Thorp and Increase Claflin, along with their families. Thanks to the preservation of the land through the state park system, the immediate area probably doesn't look much different now than it did when Asa and Increase last walked on it.

In 1945, Fish Creek was the unlikely site of a German POW camp. It operated briefly as an adjunct to Fort Sheridan in Illinois. The prisoners worked in the park and surrounding areas, clearing wood, painting, doing construction projects and picking cherries in nearby orchards. Old-timers remember the prisoners of war with a mixture of respect and amusement. They were industrious workers for the most part, who approached each task with a focused mind and a light heart, singing loud German songs as they worked. Some of the improvements in the park today are the result of the skilled and free labor provided by the prisoners. In retrospect, perhaps the incomprehensible beauty of the area—along with the hearty and familiar meals provided by locals who, not long before, had emigrated from neighboring European nations—helped to mitigate the prisoner's loneliness and fear.

Ephraim and Chambers Island

In essentials, unity; in nonessentials, liberty; and in all things, love.
—motto of the Moravian Church

Towns in Door County were founded for a variety of reasons, but most of them shared the common thread of economic opportunity—the area was rich in lumber or abundant with fish and game or located in an opportune spot on the shoreline to capture shipping trade. Ephraim was settled for a precise and higher purpose: it was established as a communistic enclave of the Moravian Church. "Ephraim" is a Hebrew term (some scholars say Egyptian) that translates to "double fruitfulness," and that is exactly what Reverend Andreas Iverson wanted for his flock when he led them to the beautiful spot on the Green Bay shoreline.

Iverson originally emigrated from Norway to teach religion at a planned Moravian community in the area that is now Green Bay. That settlement was founded by Nils Otto Tank, son of a wealthy Norwegian nobleman named Carsten Tank. Young Nils was a fervent missionary who hoped to create Moravian settlements throughout the new frontier of America. He and his family came to Milwaukee in early 1850 and began buying up land to the north on the banks of the Fox River. Tank envisioned a self-sufficient society of farms, factories, schools and a glorious church that would serve as the heart and soul of the community. His dream proceeded according to plan for a year or so, but discord between Tank and Iverson grew. Iverson was a cautious and circumspect man, while Tank was an ambitious achiever with great wealth and lofty visions. Their personalities were quite different, and Iverson grew suspicious of Tank's personal agenda. In hindsight, it

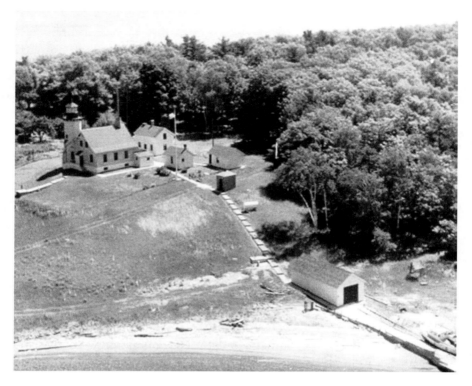

An aerial view of Chambers Island Lighthouse and station buildings.

seems that Tank was truly driven by altruistic passion, a fact that Iverson apparently regretfully acknowledged much later in life. At that time, however, the good reverend decided to seek a fresh start for the congregation, free of any hidden motives or entrapments.

In the winter of 1853, Iverson and three trusted companions—Gabriel Wathne, Abraham Oneson and Melchior Jacobs—set out on foot across the ice to visit a friend from the old country, Ole Larsen. Larsen had settled on Eagle Island (now known as Horseshoe Island) off the coast of the rugged peninsula and regaled his old friends with stories about the natural beauty and wealth of the area. The timing was perfect, because Iverson had recently received a loan of $500 from a church official in Pennsylvania and was determined to use it to launch a new colony. The morning after they arrived at Larsen's homestead, the group set out on the ice once again, this time to make the two-mile trek to the mainland. Almost immediately, the others were enchanted by the landscape, but Iverson needed a divine declaration.

He stepped away from his friends and knelt to pray in the snow among some small evergreens. After a brief period, he claimed that he had heard the word of the Lord assuring him that he had indeed reached the perfect spot to lead his congregation. Without further ado, Reverend Iverson headed to the U.S. Land Office in Menasha and purchased 425 acres for just a little over one dollar per acre. The new settlement would be called Ephraim, and the Lord's blessings would shine on all who congregated there.

By that spring, Iverson had relocated almost all of his followers from the Fox River area to Eagle Island. Their future home lay across the bay, covered in heavy timber that had to be cleared before building could commence. They camped in crude temporary shanties on Ole Larsen's land and spent their time on the mainland, chopping trees and fishing for food. By November, enough land had been cleared to build a few houses, including one for Reverend Iverson that would serve as the spiritual center for the group. For several years, weekly prayer services were held in Iverson's spacious home, until the struggling community could scrape together the means to build a proper church building. Finally, in December 1859, the white-steepled Ephraim Moravian Church opened its doors for services as the first church ever built on the peninsula. It represented the culmination of years of hard work and struggle. The congregation had suffered terrible hardships, including near starvation over the first few bitterly cold winters. The early crops were sparse and poor, and the settlers did not collectively possess enough livestock to provide staples such as milk and eggs. The steamboats laden with supplies from Green Bay were all frozen in their harbors and unable to reach the desperate and hungry northern settlements. It was, quite literally, only their faith that sustained them. Iverson never wavered in his beliefs, and his congregants followed suit, working hard and praying for the fruitfulness they sought.

Eventually, Ephraim began to grow and prosper. Lumber companies cut crude roads through the forests and swamps, providing overland access to Sturgeon Bay and Green Bay. The settlers cleared more farmland and coaxed crops out of the fertile but shallow topsoil. In 1864, Iverson was forced to leave the community that he had cherished and built when church elders asked him to move on to other fledgling settlements. His grief and reluctance was apparent in his notes from that time: "Never can I express my feelings as I tarried a few hours in my home, now to be given up forever…I burst into tears and in bitter sorrow called out a last farewell." Today, Iverson's home remains standing in the same location as it was built in 1854, and is the oldest frame house in Door County.

The Ephraim Historical Foundation faithfully restored it to what it was in 1885, based on precise notes and letters from another minister's wife who lived there with her husband after Iverson's departure. The simple white building stands as a monument to the man whose vision and backbreaking labor brought the town into existence.

In fact, Ephraim is home to several historic buildings that tell the tale of its past as a struggling frontier town. Perhaps the most famous structures are those built by Aslag Anderson to house his family and his businesses. Anderson was a Norwegian immigrant who came to this country in 1849 and settled in Milwaukee. After a while, he heard talk of the new up-and-coming Moravian settlement sheltered in the deep northern woods along Green Bay. He and a friend, Peter Peterson, visited the town and quickly decided that it was the perfect spot to build a dock for the ships that plodded up and down the coastline. And so, in 1858, the men paid the congregation $200 for about 150 acres of land along the water and set to work building a dock and warehouse. The Moravians were quite pleased with the venture, because it meant that vessels bearing necessary goods could reach them with relative ease. Also, the church members had found quite a profitable business niche in cutting telegraph poles and fence posts for growing cities to the south in Illinois. The tall, straight cedars that lined their land were perfect for the purpose and

Eagle Harbor in Ephraim was once a shipping port but now draws fishing and pleasure boats.

needed to be removed anyhow to clear fields for farming. They only needed a reliable method to transport the valuable timber. Soon, supply ships began landing at the Anderson Dock on a regular basis. Later, as tourism came to the county in the 1880s, the Goodrich Line also made scheduled stops at Ephraim, disgorging travelers into the welcoming arms of the community.

As the dock and warehouse were being constructed, Anderson turned his attention toward building a store. He knew that the settlers desperately needed a local purveyor of sundries to spare them the arduous trips to Green Bay for needed supplies. The Anderson Store was completed in 1858 and quickly became the social hub of the community. It was stocked with everything that a general store of the era might carry: flour, coffee, tobacco, patent medicines, fabric and tools. The one thing it didn't carry was liquor; Ephraim is, to this day, a "dry" community. In fact, it remains the only dry municipality in the entire state of Wisconsin. In spite of this, the town was neither humorless nor overly pious and received visitors to its shores with friendly hospitality. The store remained in the Anderson family for more than one hundred years, until it closed in 1958 due to the advanced ages of the remaining heirs. In 1966, the village purchased the boarded-up building and worked with the historical foundation to reopen it as a living museum. To its delight, it found that the thrifty Norwegians had never discarded unsold merchandise but rather had simply packed and stored it in the store's attic. Troves of authentic clothing and other items were squirreled away in the original boxes. The family had also kept the store fixtures, such as wooden counters, a cash register and an old potbellied stove. Using old photos, the foundation was able to re-create the store almost exactly as it had appeared one hundred years earlier. Today, docents in period dress run the store, selling penny candy and souvenir items while they walk visitors through an uncanny re-creation of pioneer life.

Of course, through modern eyes, it's often difficult to appreciate just how hard and tenuous life in the frontier must have been for the early populations. Even as recently as the early twentieth century, homesteaders struggled to survive and feed their families in an environment that was often as hostile as it was beautiful. Rocky Fairchild, who was born in Fish Creek in 1927 and has spent most of his life on the peninsula, recently recounted a tale of life in the early days. When Rocky was only eight days old, his family moved to Chambers Island, about eight miles off the coast of Ephraim. The island was named after Colonel Talbot Chambers, who saw the land mass as he sailed past in 1816 on his way to head up a military post in Green Bay. By the 1850s, the island was home to several settlers, and a lighthouse was added

in 1868 to guide mariners past its northwest shore. Eventually, the early settlers left, and much of the land fell into the hands of a wealthy furniture maker, who used its vast tracts of hardwood to craft fine tables and chairs. After Rocky's birth, his father accepted a job as a caretaker for the island and moved his wife and growing family to the rather desolate spot. The Fairchilds, however, weren't the only ones living on the land; the lighthouse keeper, his assistant and another caretaker named Ed Casperson all lived there as well, along with their respective families and a few fishermen.

In order to get food and supplies, the islanders depended on boats during the summer and sleds across the ice in winter. The only time when they were truly cut off from land was during the early winter, before the ice had completely frozen, and spring, when the ice was breaking up and shifting. Bay ice doesn't melt but rather breaks up from wave action and drifts far out into the lake in small floes that slowly disappear as the weather warms. During these times, the ice floes are too thick and clustered to break through in small boats but too weak and broken to support a horse and sled. Residents of the island anticipated these periods and laid in plenty of supplies to carry

Early stores such as this cigar and sundries shop often served as social hubs in the community.

them through until the bay once again became navigable. In the winter of 1928, however, the ice breakup began unusually early, but waves kept the floes near shore instead of pulling them out into open water. As their food supplies dwindled, the men despaired of how to feed their hungry families.

Days dragged into weeks, and still the shattered ice remained. Finally, in desperation, Mr. Fairchild and a few other men decided to walk the eight miles to shore, stepping across the broken floes. The round trip by foot should only have taken two days, but the days came and went with no sign of the men. The women prayed and tried not to think of the possibility that all had fallen through the ice and drowned or had been carried to sure death on a fragile raft of ice into the open water. After four days had passed, Rocky's mother was nearly mad with worry about her missing husband and yet still faced the prospect of starvation with her three young children. Finally, she could no longer stand at the shore and pray. She bundled her toddlers, Norman and Arnold, into heavy clothing, strapped baby Rocky to her body and proceeded gingerly out across the ice toward the far-away mainland. She hadn't gone far when she heard a distant shout. As she squinted against the blinding glare, she spotted her husband and the others making their way across the ice, laden with food and supplies. Their journey had been extremely treacherous and tedious. Large sections of open water or thin, cracked ice had confronted them, and they had to hunker down in the freezing wind and wait until a more substantial floe drifted past. In this manner, they had jumped and hop-scotched across the bay, risking their lives to save the families they had left behind.

Today, Chambers Island is sparsely populated by summer residents. The lighthouse was decommissioned in 1961 and replaced by a steel tower with an automated light. The original buildings are now owned by the Town of Gibraltar, which maintains the historic site. Although the grounds are open to the public, the tower is closed, except for the yearly Lighthouse Walk tours, which briefly allow visitors to view a glimpse of life from the island's earlier days.

Egg Harbor

Loveliest of trees, the cherry now is hung with bloom along the bough.
—A.E. Housman, English scholar and poet

In 1861, Egg Harbor became the tenth town to be organized in Door County. Although much of the history of the beautiful little settlement is carefully recorded, the origin of its name has proved to be an elusive mystery. Theories abound, but no one can agree on the defining event. Some attribute the name to the slightly oval shape of its harbor; others claim that it was named after an early settler discovered a nest of duck eggs on the shore. A few of the tales are quite specific and detailed, claiming that Mr. (or Mrs.) Increase Claflin discovered a nest of duck (or seagull) eggs while retrieving a horseshoe (or tool) from the water's edge. Oddly enough, the most unlikely story is the one that also has the most credence, as it was documented in an 1862 edition of the *Door County Advocate* newspaper.

In this version, a half-dozen fur-trading Mackinac boats traveling from Green Bay to Mackinac Island stopped to anchor in the harbor one evening in 1825. As the sailors rowed to shore, they began to tease and boast about who would reach land first. The friendly competitors began to toss things at one another in play. When they reached the shoreline, they discovered numerous seagull nests and began throwing the eggs at one other. A witness, Mrs. Elizabeth Baird, recorded the fight in her journal and noted that the battle went on until they had run out of ammunition and that the men "laughed until exhausted." After they departed the next morning, the carpet of eggshells remained, and the area was forever known as "Egg Harbor." Whether this story is true—or just a fanciful explanation—will never be

An aerial view of
the vast cherry
orchards that grace
Door County.

known, but it's as good a story as any and a fitting tribute to a town that is
friendly and pleasant to visitors.

The first permanent settlers were Jacob and Levi Thorp, younger brothers
of Fish Creek founder Asa Thorp. Like their older brother, Jacob and Levi
came to the area to cut lumber and built a pier and other structures to
accommodate the business. Eventually, Jacob moved on to other pursuits, but
Levi stayed and enticed farmers to settle on the now cleared land. It wasn't an
easy sell; although reasonably fertile, the soil was shallow, sitting immediately
atop the peninsula's limestone base. Fortunately, Door County's location
between two large bodies of water created an unusual climate, quite similar
to the apple growing regions of the West Coast. The warm days and cool
nights are perfect for orchard fruits such as cherries and apples, and it wasn't
long before the county lanes were lined with cherry orchards that stretched
for miles. Soon, Door County became one of the primary cherry producers
in the nation, with more than 3,200 acres of the fruit planted. Apple orchards
joined the mix, with many varieties planted, although never in the same
volume as the beloved Montmorency tart cherries. Wineries created and sold
cherry and apple wines for the tourists and became popular attractions. The
vintners soon realized that grapes would grow well in the same environment
as cherries and apples, and in recent years vineyards have sprouted up among
the cherry orchards. The grapes are of good quality, and Door County
wineries now refer to the area as the "Napa Valley of the Midwest."

Most importantly, the cherry orchards brought jobs and settlers to the
region. As the old-growth forests disappeared under the lumbermen's
axes, the county needed new sources of income to supplement the small
farmers and fishermen who remained. Tourism was growing, but agriculture

provided a more predictable and manageable form of sustenance. In the early days, cherries were picked by hand, and migrant workers arrived in droves from steamboats and trains for the seasonal work. Still, it was difficult to hire enough labor to harvest the huge crops. In 1917, the crop yield filled 230 railcars to the brim, and growers predicted an even larger yield for 1919. In order to create another market beyond the fresh cherry business, a group of growers got together and formed the Fruit Growers Canning Company in 1918. This allowed them to extend the shelf life of the fruit and ship it to markets across the country. By that time, it was becoming increasingly obvious that handpicking was too labor intensive to sustain the industry, and the University of Wisconsin Agricultural Engineering Department began work in earnest to develop a mechanical cherry harvester.

The first model was a primitive design that consisted of two wings that would wrap around a large branch and shake the cherries loose, whereupon they would fall onto a canvas stretched below. It still required workers to reposition it at each limb and wasn't of much use on slender limbs. As such, it was highly inefficient but was still a time and cost saver over migrant labor. Each successive model improved the design a little bit and made the job just a little bit easier. Today's shakers attach to the tree's trunk and shake the entire tree at once. It now takes only about seven seconds to harvest about seven thousand cherries off an average tree, enough to make more than two dozen large pies. By moving at a quick pace, an orchard worker can now harvest up to one hundred trees per hour, a job that would have required many hours of tedious labor for the migrant workers. Once the cherries are collected, they're dropped into chilled water before being sent for processing. This helps preserve the fresh taste of the fruit and prevents any degradation. They are then packaged for fresh consumption or pitted and frozen or canned. About 95 percent of Door County cherries are the iconic tart Montmorency, with just a relatively few acres set aside for sweet cherries. Although its days as "Cherryland USA" peaked in the 1950s, cherries are still an important part of the economy for Door County and are ubiquitous throughout the area. A devastating frost in 2008 wiped out nearly the entire crop, but the trees—and the farmers who pamper them—bounced back from the disaster.

Of course, cherries are not the only crop in Door County, just the most plentiful. Fields of corn and soybeans grace the rolling hills, and dairy farm pastures dot the landscape. The early settlers had to walk their livestock across the ice from farms in the Fox River Valley or points beyond or else drive the animals in a perilous and lengthy trip through forests and swamps. During its earliest years, Door County was mostly devoid of cattle; there simply wasn't

Door County is awash in cherry blossoms each spring.

enough open pasture on which they could graze. As the lumbermen cleared tracts of forest, the meadows grew up in their place to sustain grazing herds or farm plots. Today, much of the interior of the peninsula is open pastures and farmland, but the shores are more heavily wooded.

As the tourists arrived in force, the local farmers found a way to earn a little extra cash from their enterprises. Farmer's markets, U-Pick orchards and petting zoos began to spring up around the towns in a fortuitous mix of agriculture and entertainment. Area hotels and restaurants touted the local fare, and every eatery worth its salt concocted a proprietary version of the infamous Door County cherry pie. Many of Egg Harbor's early inns and homes remain standing today, including the beautiful Cupola House, a Gothic Revival mansion built by Levi Thorp in 1871. Thorp wanted the mansion to be perfect and allowed only lumber that was free of knots to be used in the building. According to local lore, Thorp paid for the construction with gold he had gathered in California during the gold rush of 1849 and wore in a chamois money belt around his waist. The house was listed on the National Register of Historic Places in July 1979 and was opened to the public for the first time in 1982. It now houses an art gallery, shops and a small café.

One of the other old buildings that remains from Egg Harbor's early days was originally opened in the late 1800s as the Kewaunee House. It served as a boardinghouse for lumbermen and sailors and included a small saloon. In 1904, John Bertschinger, a Swiss immigrant, purchased it and expanded the building to include a dining room and renamed it the Harbor Inn. By 1912, Bertschinger had had enough of the innkeeper's life and sold it to Murphy Moore. "Murphy's" remained popular for many years and became a notorious hangout for Chicago gangster Al Capone. There are tunnels

Thousands of migrant workers descended on Door County each year to handpick the cherry crop. Now a harvesting machine can gather the cherries from a tree in just about seven seconds per tree.

under the building that lead to nearby Murphy Park and other points around town and that allowed Capone to beat a hasty escape if federal agents or other unwelcome visitors showed up asking questions. In 1997, the building became a restaurant and bar named "Shipwrecked"; it is also the lone microbrewery in a county filled with wineries.

The current owners claim that the building is haunted by numerous ghosts from its colorful past. Verna Moore, the deceased wife of former owner Murphy Moore, is said to wander the halls in a motherly fashion, checking to make sure that all is well. Some of the other ghosts, however, hearken back to the inn's more sordid past and are decidedly less pleasant than Mrs. Moore: a boy named Jason was supposedly the illegitimate offspring of Al Capone and was found hanged many years ago in the building's attic; two federal agents came to town in the 1920s to arrest Capone and were never seen again; a murdered logger with a surly disposition returns on occasion to the site of his demise.

Quite a few deaths and disappearances have been associated with the building over the years, so it's likely that the ghostly visitors are feeling a bit crowded these days. In any case, it's a fine spot to relax and soak up some local history. And if a pleasant-looking silver-haired lady glides past to see how you're doing, don't be surprised if she seems to vanish into thin air; it's probably just Verna Moore, stopping for a moment to greet the guests.

Part III

The Quiet Side of the Door

JACKSONPORT

One suggested Harrisport, another Reynoldsport, a third Jacksonport. As Jackson was the father of the enterprise, the last name was chosen in honor of him.
—H.R. Holand, author and historian

The town of Jacksonport hugs the Lake Michigan shoreline, about fourteen miles north of Sturgeon Bay. It was once the site of a thriving Potawatomi settlement known as *Méchingan*, but by the time the white settlers appeared in the mid-1800s, the native population had long since been driven from the area. All that remained to tell the tale of their village was a burial ground and scattered artifacts, which are still being unearthed to this day in the nearby farm fields or along the rocky coast.

Neil Blair, a fisherman and farmer, was the first known white inhabitant. He was joined in 1861 by Perry Hibbard, who settled near the mouth of the creek that would later bear his name. Hibbard had come to the area for its limitless opportunities in lumber. He built a small general store and dreamt of building a shipping dock to accommodate trade in the area. About the same time, a small consortium of fortune seekers from Madison, Wisconsin, had caught wind of the unspoiled stands of timber on the rocky peninsula and filed a preemption claim to obtain some land along the shoreline. Colonel C.L. Harris, John Reynolds and Andrew Jackson drew up plans to cut the timber and then sell the land as homesites once they had culled its natural resources.

Because the land was on the Lake Michigan coast, it would be a simple matter to transport the lumber down the lake to Milwaukee and Chicago,

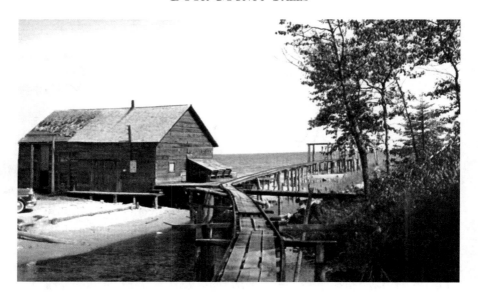

A fish house and dock along the Jacksonport shoreline.

both of which clamored for building material to fuel their explosive growth. To do so, however, would require a shipping dock. The group approached Hibbard, whose land included the general store and the fast-flowing stream that would make the location a perfect spot for setting up a freight depot. Hibbard agreed, and with funding from the Madison speculators, he built a sturdy pier into the lake to accommodate the lumber schooners that would soon land in droves to carry off the riches of the forest. A band of thirty-seven lumbermen led by John Reynolds's brother, Thomas, arrived and set up camp in Hibbard's log barn, and it appeared that the new lumber camp would be a rousing success.

Unfortunately, the company was plagued with problems from the start. The lumbermen were inexperienced and their methods wasteful and costly. The winters were harsh and food was scarce. Author H.R. Holand tells a wry story that illustrates the bad luck of the team and what was perhaps the final breaking point of the venture. One morning, shortly after Tom Reynolds had arranged for a full shipment of provisions, the company cook entered the amply stocked storeroom to find that a skunk had gained entry overnight. After much discussion about how to safely evict the wandering polecat, the cook grabbed a shotgun and went in for a quick kill. It wasn't quick enough, however, and the skunk had the last laugh. In the blink of an eye, all of the precious provisions were irrevocably fouled. More than a ton of butter,

The Quiet Side of the Door

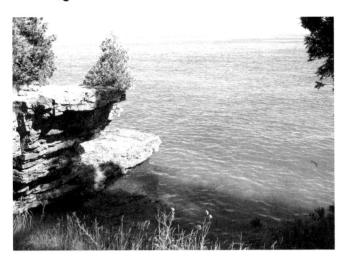

Stone outcroppings and underwater caves gave Cave Point Park its name. *Photo by Peter Rimsa.*

thousands of pounds of pork, beef and flour and other assorted sundries had to be discarded due to the incredible stench. It was the last straw. Many of the men deserted, heading back to Madison in search of an easier way to make a living. The company suffered a great hardship not only from the loss of the expensive rations but also from the work disruption it caused. Shortly thereafter, the company of Reynolds, Harris and Jackson went bankrupt. Tom Reynolds decided to remain, however, and settled on seven hundred acres of land that he built into one of the largest farms in the area.

After a while, Reynolds and Hibbard were joined by a wave of new immigrants, primarily French Canadians from Quebec and, later, Germans and Austrians. In the late 1800s, Jacksonport was a bustling town, with general stores, a meat market, wagon shops, blacksmith shops, hotels, taverns and a sawmill. Boardinghouses provided shelter for the lumbermen who came to cut the valuable cordwood that would be loaded onto the incessant stream of schooners that docked at Hibbard's pier, hungrily seeking a load for the willing buyers in the bustling cities to the south. By the turn of the century, Irish, English and Scottish families arrived, as well as Yankee pioneers from New York and New England. Unlike some of Door County's other towns, which remained somewhat insular with their founding nationalities, Jacksonport was a melting pot. By this time, much of the surrounding land had been cleared of timber, and the area was rapidly evolving into a farming community. Fishing also remained a valuable source of income, and ten commercial fisheries once flourished on the shores. Trout and whitefish were plentiful, and fishermen pulled in many tons of these fish with gill nets suspended between boats.

Although some of the fish were sold fresh to local customers, most were packed in salt within wooden barrels. This method acted to preserve them and also created a healthy trade for talented coopers (barrel makers) in the area. A successful fisherman might go through several hundreds of barrels during the season, and they needed to be sturdy and watertight. The cooper would cut the staves, hoops and headings by hand and then assemble them through a somewhat laborious process of soaking and drying, finally fitting the wood in a manner that rendered it impervious to leakage. Barrel making was often a winter job, as the fisherman used that time to prepare for the season ahead. Contrary to how it might appear to an outsider, the farmers and fishermen did not rest during the frigid and bleak winter months. There was always work to be done: nets to mend, boats to repair, animals to house and feed and crops to be planned. Only the industrious prospered—or even survived.

Eventually, the residents of the area realized that there was another untapped resource at their fingertips: the varied and beautiful coastline, which was beginning to attract tourists from near and far. Jacksonport has two natural treasures nearby, and both have since been turned into protected parkland. The first is Cave Point, a rocky section of coastline that features sheer limestone cliffs, underwater caves and a "beach" that is a solid limestone shelf. In high-water years, the lake reaches all the way to the cliffs, and the

Door County has always been a fisherman's paradise.

lower ledge is inaccessible. The carved and sculptured bluffs are beautiful even in calm waters, but it is when Lake Michigan's waves strike that nature really puts on a show. The breakers roll into the caves with a thunderous roar, sending spray dozens of feet into the air. Some days, the mist hangs in the air, refracting rainbows in the sunlight. When the seas are heavy, the spectacle is overpowering and the sound deafening. Water runs across the rocks and down through fissures and then cascades into waterfalls in the caves below. Fog shrouds the paths, tempting any mortal fool to venture too near to the steep cliffs. The wind whips at the ancient cedar trees that cling to the rocky precipice, and it is suddenly very easy to sense the fear and awe that must have confronted early mariners who sailed along this inhospitable shore.

One ship that met its demise at this spot was the schooner *D.A. Van Valkenburg*. In September 1881, it sailed from Chicago with thirty thousand bushels of corn, headed northeast for Buffalo, New York. A terrible storm blew up, and the ship was tossed relentlessly on the waves. After two days and nights of battling the gale, the wind and surf drove the schooner onto a reef. The crew believed that they were near Michigan's Manitou Islands, but in reality they had been swept off course fifty miles to the west and had foundered on the rocks of the Door Peninsula. As the angry whitecaps splintered the decks out from under them, the nine crewmen tried to swim toward the dark silhouette of land just to the west. Although they were mere yards from shore, the waves picked them up like toys and dragged them back out into open water or smashed them mercilessly against the jagged rocks. Only one sailor, Thomas Breen, managed to cling tightly to the cliffs and pull himself from the roiling waters. Bruised and bleeding, he lay on the shore until morning light, when he finally gathered the strength to limp to the nearby town.

By the time rescuers arrived at the wreck site, there was no sign of the ship or the other eight crew members. As the storm calmed, pieces of the shattered hull were finally visible underwater near the reef, and bits of debris started to wash ashore. Eventually, four bodies were recovered, but the rest were never found. Within days, however, the corn cargo started to wash ashore—lots of it. Residents of Jacksonport began to collect it for use as pig feed, but it seemed that the more they scraped up, the more that appeared. Soon it seemed that they had salvaged enough to feed all the livestock in the county, yet the lake continued to offer up more. Some old-timers claim that it began appearing on the bay side of the peninsula a few days later. Although many scoff at this, it's entirely possible given the wave patterns and currents of the area, especially in autumn, when northeast winds force Lake Michigan waters into Green Bay.

Cabot Lodge in Sturgeon Bay was typical of tourist resorts of the early 1900s.

Just south of the brutal cliffs, the land tapers gradually to peaceful, undulating sand dunes and a beech forest now known as Whitefish Dunes. The dunes are the largest on Lake Michigan's western shore and are host to many endangered grasses and other plants. Archaeologists have discovered remains here from eight successive prehistoric indigenous populations, garnering the land a place on the National Register of Historic Places. Most of these predate the documented Potawatomi village near Hibbard's Creek, and little is known about the earliest inhabitants. The area, however, was one of the most logical for a settlement: the sandy shoreline created a relatively safer landing point for native canoes, tall dunes offered plenty of visibility to keep watch for unfriendly intruders and the surrounding forest held a wealth of game and necessary firewood. Whitefish Bay, however, is not as innocuous as it might appear. The curve of the shoreline amplifies the waves and creates capricious and ferocious riptides. Nearby Clark Lake, which sits parallel along the shoreline of Lake Michigan, was once probably a part of the bay, but it was cut off by eons of wave action and silt deposits. Its sandy beaches offer a safer alternative for swimmers than the unpredictable waters of the big lake.

With all of this varied natural beauty, it was inevitable that the tourists would arrive, and Jacksonport was ready for them. Early hotels such as the LaMere Lodge and the Eureka House sprang up to accommodate the

Tourists came to swim, sunbathe and commune with nature.

visitors. The Eureka House featured not only boarding but also a small post office so that visitors could send postcards to loved ones back home. At the turn of the century, the U.S. Postal Service had a goal to open offices near almost every settlement, so that residents didn't have to travel far for mail. Some of the "offices" amounted to nothing more than a locked wooden box on a shopkeeper's shelf, but nevertheless the system worked. By 1902, thirty-six post offices were spread across the county. Now there are only eleven, and vacation postcards are quickly being replaced by e-mails or Twitter posts.

The town itself has changed a great deal since its founding but still displays the quiet country charm that defines life on the peninsula. Hibbard's dock is long gone, but the creek that runs through the area still bears his name. Lumbermen no longer stop for a bit of respite at the local taverns, but farmers and tourists have taken their place. The buildings are a mix of old and new, and antique stores display goods that once graced local homesteads. The only thing that hasn't changed much is the restless lake, poised on the town's eastern edge. It sits as it has for millennia, a source of pride and sustenance but also a bringer of pain and destruction to those who don't respect its inherent power.

BAILEYS HARBOR

A discovery is said to be an accident meeting a prepared mind.
—Albert Szent-Gyorgyi, Hungarian biochemist

One of the first things to know about Baileys Harbor is that its name is misspelled. Well, not misspelled, exactly, but missing a crucial bit of punctuation: the apostrophe. No one seems to know exactly when—or why—the elusive apostrophe disappeared. Some townsfolk swear that it was the result of an official town vote way back in the hazy history of the settlement. Others shrug and guess that it simply fell away during an era when people had more important things to worry about, such as basic survival. In any case, the town's official name has annoyed proofreaders ever since.

Baileys Harbor was discovered in 1848 during one of the vicious late fall storms that ensnare the area with relentless frequency. Captain Justice Bailey, a seasoned mariner who ran shiploads of grain and other commodities between Milwaukee and Buffalo, was on his way back to Milwaukee when the lake began to seethe. His return load was light on freight but heavy with passengers; Bailey was transporting a load of immigrants eager to claim a piece of land in the great unsettled frontier. As his ship rolled and tossed in the waves, the captain feared for the safety of his crew and his precious human cargo. He was quite familiar with the deadly, rocky eastern shores of the uncharted Wisconsin peninsula, and he had heard the tales of those who had tempted fate in these waters and never returned. He had to make a difficult choice: struggle on toward Milwaukee, and likely founder in the gale, or attempt to put down anchor and pray that the crashing waves didn't drag his ship onto the rock-strewn shoreline.

Maxwelton Braes Golf Resort in Baileys Harbor was the epitome of fine living when it was built in the 1929. It remained a destination spot for weddings until recently, when the clubhouse and restaurant were closed. Although the golf course remains open, the town hopes that new owners will take over and reopen the iconic resort.

Suddenly, Bailey spotted another option. Off his starboard bow was the outline of a small, protected harbor! It was a risky proposition; if the water was not deep enough, or if the entry was lined with rocks or the skeletons of other ships that had sought haven here before, he might be steering straight into the arms of death. On the other hand, death seemed a near certainty in the hellish waves and raging wind on the open lake. With barely a second to decide, he turned the ship's wheel and headed for refuge. To his relief and delight, the welcoming harbor was deep enough and entirely sheltered from the tempest outside its banks. He dropped anchor and hunkered down to ride out the storm.

By the next morning, the weather had relented, but by this time the captain and crew were more than a little curious about the spot at which they had landed. Some of the passengers also hungered for a little respite from the rolling ship. The crew dropped rowboats, and a small expedition set out for the nearby shore. To Bailey's amazement, they set foot on a land that was richer in natural resources than he had ever seen. Thick forests of pine, cedar, maple and beech stretched as far as the eye could see. Nearby, rock ledges of easily accessible limestone begged to be quarried. In the dense underbrush, they discovered a bounty of wild raspberries and blueberries,

A live orchestra provided entertainment at Maxwelton Braes.

which must have seemed like the food of the gods after the onboard rations of salt pork and flat bread. The harbor was teeming with a variety of fish, and wild turkey, deer and other game moved quietly through the timber. The group did not encounter any human inhabitants; only a few pioneers had yet found their way to the Door Peninsula, and most of them were settled on the bay side.

Captain Bailey was a shrewd and meticulous observer and realized that this unclaimed land could yield a fortune to the man who staked a claim. And he knew just the man who had the wherewithal to do so: his employer, Alanson Sweet. Sweet was a native New Yorker who had moved west in 1835 to embrace the new frontier. He settled in Milwaukee, where he owned a fleet of ships and made a living trading grain and supplying lumber, stone and building materials to pioneer tradesmen. He was also quite active in politics, serving as a member of the Territorial Upper House before Wisconsin declared statehood and later as a Milwaukee alderman. He was a vocal supporter of railroads and plank road development, and Bailey knew that Sweet would be quite interested in the delightful hidden harbor he had discovered. Bailey and the crew carefully gathered samples of timber and stone to bring back to Milwaukee, and the captain sketched out a detailed map of the area.

Upon his safe return from the harrowing voyage, Bailey regaled Sweet with stories of the untapped and bountiful area and proudly showed off his samples of prime pine, beech, maple and high-quality dolomitic

The Quiet Side of the Door

An early causeway across Kangaroo Lake.

limestone. Sweet was indeed intrigued and immediately filed a claim on the land. As soon as winter faded into spring, he dispatched crews to create a work settlement. Their first task was to build a pier, a sawmill and storage buildings so that the commodities could easily be shipped. And because there was a growing amount of shipping traffic occurring on the Green Bay side, Sweet's men decided to carve out a road across the peninsula so that their wares could be moved overland to interested buyers arriving from the west. That early road still exists today as County F, the first thoroughfare ever built in the county.

Bailey's description of the area's riches was accurate, and soon the settlement (referred to as Baileys Harbor) was cutting and milling lumber at a rate of about 1,500 cords per season. They also established dolomite quarries, cutting huge blocks of the valuable stone for use in the building trade. In fact, the impressive breakwaters and seawalls that grace Chicago's lakefront were largely built with Door County dolomite. As opportunities grew, so did the population, and within a short time the area was dotted with log cabins and general stores. The new birdcage lighthouse built by Sweet at the entrance to the harbor beckoned to passing ships, and it appeared that the small community would soon be a major population center.

Flushed with success, in 1851 Sweet approached the new Wisconsin legislature. Wisconsin had just joined the Union in 1848, and legislators

were still busy parceling out the land and setting up local governments. He requested that the peninsula be named as a county, and Door County, a simplification of the original "Porte des Mortes" name, was officially born. Sweet also knew that a county would require a county seat, and what better place than his new settlement? Before that could happen, however, he believed that the town needed a more impressive name, one that extolled its virtue better than the simple possessive moniker of a humble sea captain. He decided to name it "Gibraltar" after the imposing and legendary monolith at the end of the Iberian Peninsula in Europe. It was a somewhat fitting comparison. The European edifice, which was recognized as one of the mythological Pillars of Hercules, also marked entrance to the waters known as "Non plus ultra," which translates to "Nothing further beyond." The name served as an ominous warning to mariners foolish enough to venture past the foreboding cliffs, where they might be eaten by sea monsters or fall off the edge of the world. Likewise, the rocky cliffs of the Door Peninsula also served as a warning to those headed toward the feared Porte des Mortes strait, where death would surely await. And so, with great expectations, the new town of Gibraltar became the county seat for the new Door County. Unfortunately, fate always seems to step in once complacency arrives, and a severe economic downturn struck the country. Sweet's holdings were heavily

Boynton Chapel in Baileys Harbor was built in the style of a Norwegian Stavkirke church.

affected, and he abandoned his outpost and moved to Kansas to pursue new opportunities. Eventually, he moved back north to Evanston, Illinois, where he died in 1891.

After Sweet's departure, Gibraltar's fortunes began to dwindle as well, and the town was largely deserted for a few years except for a handful of trappers and fishermen. In 1858, the growing settlement of Sturgeon Bay stepped in and claimed its place as county seat after determined representatives trekked for days through the dense forest and posted notices of their intent among the trees of Gibraltar. During its seven-year reign in the position, no official county business had ever been conducted in Gibraltar, and no one contested Sturgeon Bay's coup d'état. The town, however, still possessed all of the attributes that had first charmed Captain Bailey, and slowly the settlers and entrepreneurs returned. By this time, local folk had gone back to calling it by its original name, and this time "Baileys Harbor" stuck. In 1861, the town was officially renamed, although Gibraltar Township later grew to include the surrounding settlements of Fish Creek and Ephraim.

The new waves of settlers were mostly immigrants, and each group clustered in its own area. The Irish settled around Kangaroo Lake, while the Polish newcomers claimed land more inland. Germans, English and Scandinavians populated a central area near Sweet's original town center,

The bar and dining room at Schmitz Gazebo's Resort. The Baileys Harbor Yacht Club Resort now stands on the site.

Harborview Lodge was typical of early tourist lodges in the county.

and French colonists moved into an area along the shoreline that became known as "Frogtown," a name that persists to this day. Of course, the more diplomatic and politically correct folks of modern day often claim that the area simply gained its nickname from an abundance of amphibians that once populated the lakefront. In any case, the revitalized town began to grow rapidly and soon boasted several taverns, general stores, churches and blacksmith shops along with sawmills, quarries and fishing docks. A post office was established in 1860 in the corner of Augusta Wohltman's general store. By 1869, Baileys Harbor produced roughly eight thousand cords of wood and 650,000 feet of pine lumber per year, and the quarry trade flourished as well. It was soon a bustling center of commerce and a regular stop for fishing boats and freighters.

As expected, next came the tourists. Summer visitors attempting to escape the suffocating heat in cities such as Milwaukee and Chicago often fled north to the cool forests of Wisconsin. Door Peninsula, located between the freshening breezes of Green Bay and Lake Michigan, seemed a haven from the gritty industrialized towns to its south. Baileys Harbor had some of the first and finest tourist lodges, including the Peninsula House in Frogtown, Anclam's Scenic Grove Resort, the Baileys Harbor House and the Globe Hotel. To accommodate vacationers, the steamer *City of Ludington* of the Goodrich Steamship Line made a weekly round trip to the town pier to drop

An early picture of Highway 57 in Baileys Harbor. Some of the buildings pictured are still standing.

off new visitors and fetch the old ones, as well as ferried small cargo. For those who were inclined to travel by land, a stagecoach line from Sturgeon Bay made scheduled stops. Remarkably, many of these historic buildings still exist today; the old Globe Hotel remains as a private residence. Just down the street, Schram's Dance Hall and Tavern, which was opened in 1908, now houses the Harbor Fish Market & Grille. The bar's tiled tin ceiling is original and still contains bullet holes from long-forgotten feuds that occurred when it was just a frontier tavern. The hardwood floors in the restaurant are also original, and the entire building is steeped in the history of its distant past. It's easy to imagine the bygone era when you view the old photos on display.

There are other remnants of the town's earlier years. The current Baileys Harbor Cornerstone Pub operates in a stone building that at one time or another served as a general store, a casket storage building and a circuit courthouse. Nearby, August Zahn's 1906 blacksmith shop at 8152 Highway 57 now houses a bed-and-breakfast appropriately named the Blacksmith Inn On the Shore.

August's uncle, Albert Zahn, had helped him build the blacksmith shop and later left behind his own legacy just north of town in the dwelling known as Bird Park. Albert and his wife, Louise, built the two-story house by hand, with a little help from their children and nephew. It's constructed entirely of hand-poured cement slabs studded with cedar blocks to absorb moisture and prevent condensation. Albert loved to carve and decorated his home

The front range light in Baileys Harbor is an iconic landmark. *Photo by Peter Rimsa.*

inside and out with detailed wooden sculptures of birds, angels and mythical figures. Louise would paint the sculptures, and they often handed them out as gifts to friends. Eventually, tourists began to line up at Bird Park to gawk at the intricate carvings that covered the exterior of the home, and they clamored to buy. Albert was a shy and solitary man and not at all comfortable with marketing his art. He and Louise had a daughter (also named Louise) who lived in Chicago, however, and she showed her father's sculptures to buyers at the massive Merchandise Mart in the city. Almost immediately, they recognized the beautiful simplicity captured by this American folk artist and began to buy up all that he could supply. Albert died in 1953, but his art is on display at the Art Institute of Chicago and the Guggenheim Museum in New York. Bird Park fell into serious disrepair from vandals and the elements but is now being restored by a new owner.

As Baileys Harbor grew, so did the attractions and businesses in the area. Michael McArdle, a poor Door County boy who became a millionaire in the city of Chicago, returned to his birthplace to build a sprawling stone lodge and eighteen-hole championship golf course. Maxwelton Braes was opened

in 1929 to much fanfare and became a destination for tourists and locals alike. Visitors danced to live music and dined on gourmet food in the restaurant and lounge. The beautiful banquet hall was a prime spot for elegant weddings until recent years, when the resort fell on hard financial times and was taken over by the bank in foreclosure. The golf course is still operating, but the restaurant, lodge and banquet hall have temporarily been closed. Townsfolk have high hopes that a new owner will soon step in and return the resort to its former glory. McArdle also gifted the community with two other landmark buildings, St. Mary of the Lake Catholic Church and the Baileys Harbor Town Hall, which houses the McArdle Library. The distinctive stone faces of these and other buildings lend continuity to the town that is rarely seen in other municipalities. The town hall is listed on the National Register of Historical Places, along with the Globe Hotel, Albert Zahn's Bird Park home, August Zahn's blacksmith shop, William Zachow's farmstead, the Cana Island Lighthouse, the Baileys Harbor Range Lights and the shipwrecks of the *Frank O'Connor* and *Christina Nilsson*. In fact, Baileys Harbor has been described by local historians as "a town of historic buildings."

Besides McArdle, many other local people gave back generously to the area that they loved. Thomas Toft, a Danish immigrant, lived with his family in the area between Baileys Harbor and Mud Bay (now known as Moonlight Bay). Toft was born in Denmark in 1844 as Thomas Kresten Jensen and came to

By the mid-1800s, the United States Post Office was establishing offices and delivery to the peninsula. This 1892 letter from John Anclam illustrates the importance of timber and wood sales in the county.

America in 1870. Upon arrival in this country, he was dismayed to find out that his surname of Jensen was extremely common, so he promptly changed it to "Toft" after an area in Denmark he loved. He married Julia Anne Panter in 1875, and the couple had eight children. Toft worked the limestone quarry in Mud Bay until it was closed in about 1889. When he died in 1919, his widow and children, in order to make ends meet, opened a modest summer resort consisting of five small cabins near the water of their beloved Mud Bay. Their seventh child, a daughter named Emma, continued to run the Toft Point Resort long after her siblings married and her mother passed away.

Eventually, Emma befriended Jens Jensen, a celebrated landscape artist and founder of The Clearing in Ellison Bay, a folk school and retreat dedicated to nature, arts and humanities. Together Emma and Jens were a powerful voice for nature preservation and conservancy and helped found the Ridges Sanctuary at Baileys Harbor. Emma gained the nickname of "Wisconsin's First Lady of Conservation," but many worried what would happen to her land when the elderly spinster passed away. Finally, in 1967, the Toft estate sold Toft Point for a nominal fee to the Nature Conservancy, which turned over the deed to the University of Wisconsin system. Emma, who spent her last several years in a nursing home before her death in 1982,

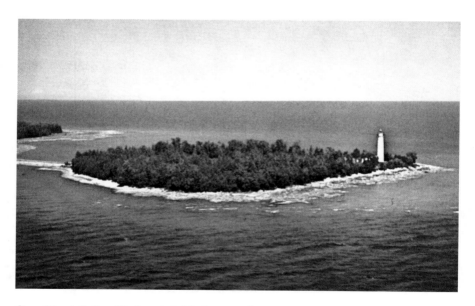

Cana Island, Baileys Harbor. At left is the natural stone causeway that connects the island to the mainland. During high-water years, it might be covered with a foot or more of water.

had the comfort of knowing that her beloved homestead would be preserved in the beauty of nature and not exploited by developers.

Another benefactor was Winifred Vail Boynton. Winifred and her first husband, Carleton Vail, were a wealthy couple from the northern suburbs of Chicago. They loved the Door Peninsula and talked of building a beautiful home on the Lake Michigan shoreline. In 1928, they discovered the perfect spot—a birch forest just south of Baileys Harbor. They purchased 325 acres, fronting over one mile of Lake Michigan shoreline, for $2,000 and began to build their dream house. They named the land Björklunden vid Sjön, which translates from Norwegian to "birch forest by the water." Shortly after they finished building a lodge, a guest house and a caretaker's cottage, Carleton was killed in an automobile accident. Winifred fled to Europe in an attempt to assuage her grief and spent a year traveling and searching for peace. While there, she saw a Norwegian stave church and suddenly knew that she must build one at Björklunden in memory of her lost spouse.

After returning from Europe, she met and married Donald Boynton, and their blended family began work on her vision. Summers were spent in Baileys Harbor working on the building, and during the winter Winifred and Donald passed time at their home in Highland Park, Illinois, by carving

Old cabins from Toft's Point Resort (1920s) that remain standing. *Photo by Peter Rimsa.*

adornments for the sanctuary. In pagan tradition, the exterior was guarded by scowling gargoyles and fearsome dragons, along with guardian bears. The interior featured religious carvings and frescoed paintings that combined biblical stories with the Boyntons' own life. For example, one section of the painted ceiling describes the Peaceable Kingdom from the Isaiah scriptures; included among the animals surrounding the Prince of Peace were the Boynton dogs, Jigger and Paddle. After nine years of hard work, Boynton Chapel was completed. As Donald and Winifred grew older, however, they realized that their lakefront paradise should serve a higher purpose after their deaths. They chose Lawrence University, a liberal arts and sciences school in Appleton, Wisconsin, as a beneficiary and steward of the property. Donald died in 1966, and Winifred died in 1974, at which time Björklunden moved into the university's hands. Today, it is used for seminars and retreats, and Boynton Chapel remains a favorite location for weddings and baptisms.

Baileys Harbor today owes much of its diversity and charm to the efforts of its former residents, who sacrificed and struggled to preserve the land they loved so well. Many of their names are deeply intertwined into the town's history and show up repeatedly in place names or through descendants who still thrive in the area. When Justice Bailey first sought refuge in the peaceful harbor more than 160 years ago, he knew immediately that he had discovered a place of uncommon beauty and natural wealth; those who have walked its shores in the years hence would certainly agree with his wise assessment.

THE TOWNS OF
LIBERTY GROVE

There are days in the heat of summer when you can taste the cool air off Lake Michigan. Nights in the dead of winter when you can hear the ice cracking on the bay. Mornings in spring and autumn when the fog creeps in over the landscape, rolling, drifting, above, all around you, lending both comfort and pleasure in its evanescence and the mournful moan sounding from the fog horn on Plum Island.
 —Norbert Blei, noted Wisconsin author and poet

Liberty Grove encompasses the northern tip of the Door Peninsula and includes the unincorporated towns of Ellison Bay, Gills Rock and Northport. Like many of their kin, these towns carved out a living through fishing and lumbering, but they also served as gateways to Washington Island to the north. Islanders came by private boat and later by public ferry to procure supplies and tend to business on the mainland. Fishermen sometimes split their time between both, living on the island for most of the year but returning to one of the northern towns to find alternate work during the harshest months of winter.

Liberty Grove was incorporated in 1859, around the time when the early immigrant pioneers began to carve out established settlements across northern Door. Community leaders met at the home of Ingebret Torgerson for the purpose of setting up the new government. Their petition called for "3 Supervisors, one of whom must be designated on the ballot as Chairman, 1 Town Clerk, 1 Treasurer, 1 Superintendent of Schools, 4 Justices of the Peace, so many Constables and as shall be ordered by the meeting, not exceeding the number provided by Law, 1 Leader of Weights and Measures,

and 1 Overseer of Highways for each Road District in said Town." The group also discussed what taxes to levy to pay for roads and other infrastructure in the new municipality.

One of the oldest settlements to fall under the auspices of Liberty Grove was a little fishing village originally known as Hedgehog Harbor. In the fall of 1855, a well-known Washington Island fisherman and boat builder by the name of Amos Lovejoy came to his favorite spot on the mainland to spend the winter. He pulled his sailboat onshore in a protected little cove at the tip of the peninsula and hunkered down to await the coming of spring. When the ice finally broke up after many long, cold months, Amos eagerly launched his boat into the harbor, where it promptly began to take on water. To his consternation, he realized that the hull was pocked with holes that had been chewed by a family of porcupines (often called hedgehogs at that time) that had wintered in the comfort of his sloop. As it sank beneath the waves, he was forced to abandon ship and swim to shore in the icy cold water. He suffered only the loss of his ship and a severely bruised ego, but news of his mishap spread quickly among other fishermen. The tale was gleefully told and retold at saloons across the area, and the cove was called Hedgehog Harbor in his honor for many years after.

In 1870, the area was renamed Gills Rock in honor of one of its most prominent citizens, Elias Gill, who was a lumberman who owned about 1,300 acres of timber near the cove and was responsible for creating some

Fishing boats at harbor dock.

of the first roads in town. Like Baileys Harbor, Gills Rock also eschews the apostrophe in its name, for reasons that are equally unclear. What is certain, however, is that the little town has a rugged beauty and tenacity that has carried it through the centuries and made it an important part of the peninsula's maritime history. It is the northernmost mainland point in Door County, and numerous shipwrecks litter its shores, making it a desirable destination for sport divers. In fact, the Door County Maritime Museum is located in Gills Rock and has artifacts and models from across the Great Lakes. The museum hosts an elaborate exhibit on lifesaving equipment, including such items as a Lyle gun, which was used for rescuing shipwreck survivors. Lyle guns were black-powder cannons that shot a weighted rescue line to foundering ships and passengers and were standard equipment for early U.S. Life-Saving Stations.

Today, Gills Rock remains a sleepy fishing village that is closely tied to the surrounding waters. The smell of smoked fish from the nearby smokehouses hangs in the air, tempting visitors into small shops and restaurants. Fishing boats and charters line the docks, and a passenger-only ferry named the *Island Clipper* makes several daily round trips to Washington Island from May through October. Although much of its commerce today is from tourism, it is still primarily about the lake; fishing and diving charters, as well as ferry traffic, draw visitors from all over the Midwest to bask in its charm. It's easy to see why Amos Lovejoy—and the hedgehogs—considered this place to be a little slice of paradise.

Just down the road a few miles east from Gills Rock is the town of Northport. Actually, it's not much of a town, but it's the northern terminus of State Highway 42 and the farthest point to which you can drive on the peninsula—quite literally the "end of the road." The two-lane highway simply fades into a large parking lot and boat ramp. It boasts a small restaurant and several houses, but the most important feature is the huge concrete car ferry dock that the Washington Island Ferry Line operates year round. The ferry line's five ships (including the retired icebreaker *C.G. Richter*) are important for tourism and are a vital link to the nearly seven hundred residents of Washington Island who would otherwise be cut off from the mainland for several months each year. A new icebreaker, the *Arni J. Richter*, entered service in 2003 and replaced the older and smaller ship. Both were named after a family of boat captains and longtime Washington Island residents who have run the line since 1940.

Carl (C.G.) Richter was born in 1881 and spent his early adulthood sailing on the schooners that carried cordwood between the peninsula and

Deep forests of tall trees covered most of Door County when settlers arrived.

Milwaukee. After a few years, he joined his brother, Frank, in a commercial fishing venture, which they continued until the early 1930s, when Frank retired and moved away. At that point, Carl bought a new and larger boat named *Welcome.* Carl and his son, Arni, used the ship to carry mail under government contract from Ellison Bay to Washington Island and also carried small freight and passengers. Author Trygvie Jensen, in the book *Wooden Boats and Iron Men*, writes about a dramatic story once related by Arni: Carl and Arni had stopped at the Plum Island Coast Guard Station one freezing winter day to pick up a crewman and his wife and five-day-old son for a trip to the mainland (probably for a first doctor visit). In those days, ships would move in against the ice, and passengers and crew would continue to shore by sleigh or foot.

On this particular day, Arni helped the young mother pick her way gingerly across the frozen waterscape, while her husband trailed behind carrying the baby. Just as the woman safely boarded the boat, they heard a scream and a splash and turned in time to see father and child slip through a crack in the ice. Richter raced toward them and arrived just as the father struggled to the surface, his newborn son still clutched in his arms. Arni grabbed the baby and sprinted toward shore, where he rapidly peeled off the child's soaked outer garments. To his great relief, the freezing water hadn't penetrated all the way through, and the newborn, although terrified and cold, was

110

unharmed. The father managed to scramble to safety, and the frightened family was reunited aboard the *Welcome*. And that's not the end of the story. About fifty-five years later, a Green Bay newspaper published an interview with Arni Richter in which he spoke of old memories and mentioned the harrowing rescue. A few days later, a man from Milwaukee called the ferry line. He had read the article and wanted to thank his guardian angel—he was the baby, now fifty-five years old, and had grown up hearing the story of his early close call with death in the waters of the Door.

In 1940, Carl and Arni bought the Washington Island Ferry Line from Bill Jepson, a purchase that included the docks at Northport and two old wooden ferries capable of carrying automobiles and larger freight. In those days, the ferries docked at Gills Rock, but when the Richters added the new large icebreaker to their fleet, Northport became the winter dock. Eventually, all service was switched to Northport, and the area was greatly improved in the 1990s with the construction of a new breakwater and extensive dredging. Arni, who had owned the company since Carl's retirement in 1953, died in 2009 at the age of ninety-eight. Today, the line is run by Richard Purinton, Arni's son-in-law. It's still quite a sight to see a full-sized tractor-trailer rig or moving van bobbing in the water on one of the ferries as it carries freight to the island.

A refreshment stand at Northport Ferry Dock kept customers satisfied while they waited for the boat. A sign nailed to the tree directs tourists to Gills Rock for speedboat rides and smoked fish.

Across the peninsula from Northport lies the town of Ellison Bay. Like its Liberty Grove cousins, it also relied heavily on fishing and lumber, and now on tourism, to pay the bills. Ellison Bay was founded by an immigrant from Copenhagen by the name of Johan Brandt Elliason. Elliason settled briefly in Ephraim, where he received his citizenship papers and quickly Americanized his name to John Ellison. Shortly thereafter, he moved to a tract of land he had purchased on the shore to the north of Ephraim. He built a pier, opened a small general store and continued buying land until he had amassed about eight thousand acres. Ellison was shrewd; he knew that the value of the timber probably exceeded the value of the land itself, but lumbering was backbreaking labor. Instead, he advertised an enticing offer to would-be farmers and homesteaders: he would contract parcels of land to interested prospects, with the agreement that they would log and clear the acreage. Ellison received the prized timber, which he could ship from his new dock. The homesteader, once the land was completely cleared, received deed to the property.

It was definitely a win-win proposition. Ellison collected all of the money from the lumbering without having to do much of anything. The farmer received free land, purchased strictly with sweat equity. Anyone wishing to farm on the peninsula would have expected to clear a plot anyhow, because every inch of land was covered by the dense forests. Many of the immigrants arrived with little more than their hopes and dreams and a strong back, so it offered them an opportunity to become landowners in a relatively short time. For Ellison, the newly established (and grateful) community would patronize his store and dock, adding yet more money to his pocket. In 1858, he was appointed postmaster, and in later years the small post office in the general store handled mail for Washington Island as well. Each day, somebody from Ellison Bay would trek to the ferry that landed at Gills Rock, hand over mail addressed to residents of the island and collect outgoing mail. By 1865, Ellison Bay was a thriving little community, and the town's name was made official. John Ellison spent his later years walking around his namesake community, chatting and joking with his neighbors, until he fell ill and died in 1908.

Even by Door County standards, Ellison Bay is a beautiful spot. The Ellison Bluff Park on the southwest edge of town sits atop one of the most dramatic dolomite bluffs on the peninsula. The sheer precipice plunges about 180 feet to the waters of Green Bay below, but that still doesn't capture the breathtaking height of the escarpment; the water is up to 100 feet deep in areas, making the full height of the dolomite cliff reach nearly 300 feet from

The car ferry *Griffin* was the first steel-hulled ship in the Washington Island Ferry Line's fleet, and it allowed the company to offer regular winter ferry service.

base to peak. For those brave enough to venture out, a catwalk suspends over the bluff's edge, allowing visitors to gaze down at the surf crashing furiously against the rocks below. Thick stands of white birch and other trees top the bluff, and on clear days visitors can easily view the Upper Peninsula of Michigan across the sparkling waters. Inland from the shoreline, the terrain is rolling and rocky. Although not ideal for farming, the land supports apple and cherry orchards and other smaller crops. Some small dairy farms appeared in the late 1800s, and cheese-making helped some of the early residents supplement their meager income.

To the west of town, the Mink River bubbles up from alkaline wetland springs and forms an estuary in its short path to Rowley's Bay, where it empties into Lake Michigan. The Wisconsin Department of Natural Resources calls the river "one of the most pristine freshwater estuaries in the country." It is home to untold numbers of endangered plants and birds and serves as a critical spawning ground for several species of lake fish. Black-crowned night herons, northern harriers, black ducks, yellow rails, black terns and sand hill cranes nest here among dwarf lake irises and federally threatened dune thistle. The area is accessible only via canoe or hiking trails and is owned by the Wisconsin chapter of the Nature Conservancy.

It was against this backdrop of natural beauty that Jens Jensen founded The Clearing Folk School at Ellison Bay in 1935. Jensen was an internationally renowned landscape artist who gained fame by designing most of the beautiful lakefront parks that grace Chicago's shoreline. He also helped establish the Cook County (Illinois) Forest Preserve District and structured the Illinois State Park system. Jensen strongly believed that man's values are shaped by his association and connection (or lack thereof) to nature. He taught that meditation and contemplation in a natural setting would clear the mind—thus "The Clearing"—and allow a higher level of thought. The school has remained a popular destination ever since, with classes in fine art and crafts, natural sciences and humanities, all anchored by a firm connection to the beautiful and quiet setting in Ellison Bay.

In many ways, the town hasn't changed a great deal from its early days. Many of the buildings and farmsteads date to the turn of the twentieth century or even earlier. One of its oldest landmarks, the Pioneer Store, has been in operation since 1900, when it was opened by Charles Ruckert. The quaint general store carried food and merchandise of all types and descriptions but, most importantly, served as the social nexus of the community. It was the location for the Ellison Bay Post Office for many years, and Ruckert was a generous and kind neighbor. He allowed the townspeople, most of whom survived by seasonal farming or fishing, to take what they needed from his store on credit. When the next crop came in or the waters yielded a fresh catch of fish, they would square up with the compassionate proprietor. The store remained in the Ruckert family until the 1950s, when it was purchased by the Newman family, who still operate it today.

Tragically, the store and some surrounding cottages at the nearby Cedar Grove Resort were completely leveled by an underground propane gas explosion in July 2006. Carol Newman, the current owner, was asleep above the store in her second-floor bedroom when the series of blasts hit during the middle of the night. Disoriented, Carol crawled to the window, only to discover that her relatively intact bedroom had been blown several hundred feet across Highway 42 and now sat at ground level on the opposite side of the street. The first floor of the store had completely disintegrated into rubble, with merchandise strewn for hundreds of yards across the road. In the nearby cottages, several members of a Michigan family attending a reunion were injured, and one couple was killed. Their three young children were not only orphaned by the blast but suffered life-threatening injuries themselves as well.

Immediately, the town moved into action to clean up the mess and, more importantly, determine what had caused the lethal blast. It turned

The Quiet Side of the Door

The car ferry *Eyrarbakki* was named after a village in southern Iceland. It can carry up to 150 passengers and eighteen cars or one large tractor-trailer rig or moving van.

out that a contractor doing electrical work at Cedar Grove Resort had unknowingly severed unmarked propane lines running underground. The leaking gas discharged into the porous limestone and built up in rock fissures underneath the buildings. No one knows exactly what sparked the explosion, but it detonated with remarkable and deadly force. Although lawsuits are still pending, investigators found no sign of criminal negligence. At the time the gas lines were laid, there was no state requirement to mark them in any manner. The electrical contractor had duly contacted the utility locator hotline before starting to dig and had only been advised of the location of some underground telephone wires. In the end, it was categorized as a heartbreaking accident, but that's of little consolation to those who lost their loved ones in the blast.

Although sympathetic and saddened by the deaths, the townspeople also grieved for the loss of their beloved store and informal community center. Some even despaired that the town wouldn't survive without the historic attraction and its feisty owner. For months, Carol Newman struggled to come to terms with the tragedy while she examined her options. Neighbors spoke of taking up a collection to help fund the rebuilding, which would be costly and difficult. The old store had been "grandfathered in" on many

code requirements over the years, but a new building would have to fully comply. Finally, Carol made her decision: the Pioneer Store would return. And in just short of a year it did return, with the exterior a near duplicate of the original. The interior looks a little different, as it has not yet gained the patina of age and familiarity that imbued the old store. However, with the addition of a few donated antiques and Carol's loving touches, the atmosphere is much the same.

Returning visitors driving down Highway 42 might not notice any significant changes in the towns of Liberty Grove since their last visit, and many residents consider that a good thing. In recent years, longtime locals on the peninsula have struggled with the issue of overdevelopment in certain areas, especially on the bay side. Although new tourist amenities can attract visitors, they can also threaten the authentic and peaceful ambiance that has made Door County such a powerful draw to travelers from around the world.

WASHINGTON ISLAND

*The fishermen know that the sea is dangerous and the storm terrible, but
they have never found these dangers sufficient reason for remaining ashore.*
 —Vincent van Gogh

Washington Island is a twenty-four-square-mile land mass that sits a little more than five miles northeast of the tip of Door Peninsula. Throughout history, it has gone through a long succession of names: the early Ojibwa Indians called it *Wassekiganeso*, which translates to "his breast is shining," a likely reference to the sun gleaming on the exposed limestone cliffs. Later maps variously called it and its nearby neighbors the Potawatomi Islands, the Huron Islands, the Noquet Islands, the Louse Islands and Islands of the Grand Traverse. In fact, Washington Island didn't receive its current name until 1816, when a small armada of schooners sailed from Mackinac, heading for the newly commissioned Fort Howard at the mouth of Green Bay. During the journey, the ships were separated, and the fleet flagship, a proud and fast vessel named the *Washington*, anchored in the island's northern harbor to allow its fleet mates time to catch up. During the wait, the crew rowed to shore and explored a bit. Because they did not meet up with any settlers, they wrongly assumed that the island was undiscovered and decided to name it and its harbor after their ship, as well as after the country's recently deceased first president.

Somehow the name crept into common usage, and gradually the other names faded away. In 1850, a few of the local residents met at Henry Miner's house on Rock Island for the purpose of founding a township, and the town of Washington was born. Although most people assume that the town only

includes the namesake main island, it actually encompasses Plum Island, Detroit Island, Hog Island, Pilot Island and Rock Island as well, although Washington Island was by far the most populous and the only one currently occupied year round.

One of the first orders of town business was to provide for a school. Almost immediately, the residents set to work building a one-room log schoolhouse on the shore near the south end of Washington Harbor. The building housed all grades, from kindergarten through high school. Although a new school building was eventually built to replace the log cabin, it remains the smallest school district in the state, with a current total enrollment of fewer than seventy-five students.

Later, in 1865, the islanders also built their first church, Bethel Seaman's Chapel. It served a congregation that consisted mostly of fishermen and mariners who had emigrated from Scandinavia in order to seek some of the

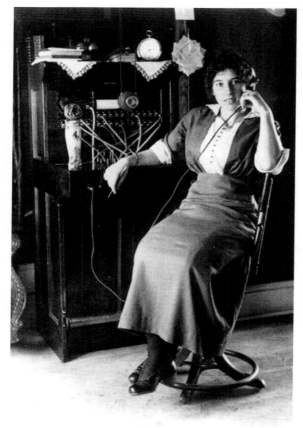

The first telephone switchboard operator on Washington Island, Miss Jepsen.

promised riches of the new land. Life on the island was hard but peaceful and rewarding. The tightly knit community worked, prayed and played together, and the little church was open to all who wished to worship. The building still stands today and offers services for the Evangelical Free Church, with which it merged in 1941.

In the 1990s, Reverend James Reiff suggested the construction of another church, one that honored the islander's predominantly Nordic heritage. A determined group of volunteers started work on a Stavkirke (Church of Staves), based on drawings of one built in Borgund, Norway, in AD 1150. Their plan was similar to that of Boynton Chapel in Baileys Harbor, but the Washington Island Stavkirke is larger. Over a seven-year period, the group spent every spare moment building, painting, carving and decorating the breathtaking chapel. It was a true community effort, with labor and materials coming from all over the island. Finally, in 1999, the project was complete. The stunning replica is owned and managed by the Trinity Lutheran Church, which holds weekly services in the chapel. A prayer path leading through the surrounding woods adds an ethereal feeling of peace and serenity to the property. It's a favorite place for baptisms and weddings and is one of the most photographed icons on the island.

The area where the school once stood is still known as Schoolhouse Beach, and the shoreline is an amazing natural oddity, one of only five in existence in the world. Instead of sand, the beach is lined with perfectly smooth, rounded or flat white limestone rocks, ranging in size from a marble to about a baseball in diameter. These stones are tumbled and polished by wave action, and their curved surfaces show no hint of jagged or irregular edges. They are perfectly formed for "skipping stones," and playful tourists throw untold tons of them back into the water. The water simply scoops them up and returns them to the beach during the next storm. And although skipping is perfectly legal, walking off with one of the strangely appealing rocks is most definitely not. Over the years, man had taken faster than nature could produce, and the beach rocks dwindled precipitously. Now the town imposes a $250 fine for anyone caught removing even a single pebble from the shore, and it means it.

Beyond the brilliant white shoreline lies Washington Harbor, a natural deep harbor of intense blues and greens. The water drops off quickly here, and only experienced swimmers should challenge the waves. It was here where early explorers and merchant ships first arrived on their voyages from the East. It is here where many ships foundered, although not in the numbers that perished off the island's southern shores. Washington Island

Schoolhouse Beach on Washington Island is one of only a few of its type in the world. The unique wave action in the harbor tumbles and polishes limestone rocks, resulting in a beach covered by smooth, rounded stones instead of sand.

actually boasts four harbors: Washington on the north; Jackson on the east; West Harbor on, well, the west; and Detroit on the southern edge. Detroit Harbor is where the ferries from the mainland dock, bringing cars, people and supplies back and forth between the island and the peninsula. It is, to a large degree, the island's lifeline. The modern icebreaker *Arni Richter* is usually able to keep a channel open year around, but that wasn't the case in earlier times. Back then, residents could only travel to the mainland during the winter over perilous ice roads, by sleigh or by foot. All too often, a cracked or thin spot of ice spelled doom. Even if the unlucky traveler managed to climb out of the freezing water without drowning, hypothermia and frostbite would quickly set in, making drowning seem a relatively pleasant option. To those who spend their lives firmly planted on the land, the thought of walking—or worse yet, riding in a heavy, horse-drawn sleigh—for five miles over unpredictable ice covering very deep water sounds rather insane, but early settlers sometimes had no choice. Driven by starvation or some other pressing need, the ice was their only avenue to survival.

Unfortunately, the old cliché that familiarity breeds contempt is all too often true. Islanders' lives revolve around the water, and sometimes they seem to lose the natural fear and caution that makes landlubbers grip their

Gill nets are hung out to dry on huge spindles.

lifejackets in white-knuckled terror at the first sign of a passing wave. One of the most tragic examples of this occurred on March 9, 1935. A group of young men from a Washington Island basketball team played in a match in Ellison Bay. Several carloads of fans and players, as well as their coach, made the trip by car over the ice. They spent the night on the peninsula and made plans to meet up the next morning to drive back caravan-style. The only proper way to make the trip involved a long westward detour to avoid the strong currents between the islands, which could weaken the ice and make it unsafe. When several of the group didn't show up at the appointed time the next morning, the coach, Ralph Wade, decided to go on ahead with five of the players. Friends begged them to wait, believing that there was safety in numbers, but Wade was impatient and needed to get back to the Washington Island tavern that he owned. And so, at about 11:30 a.m., six of them piled into Wade's two-door Model A Ford sedan and motored off across the ice.

When Wade's bar didn't open that afternoon, regular patrons became worried. The townsfolk soon realized that several of their own were missing and organized a search party. Eventually, the searchers came upon a large, ominous, jagged hole in the ice near Plum Island. The Coast Guard arrived with icebreaking equipment and began the long process of dragging the deep waters. After a few days, they made a grim discovery: the Model A Ford, with the bodies of Roy Stover, Leroy Einarson and Raymond Richter (of the

Ferry Line family) still wedged in the back seat. They continued to search for the others and eventually were able to retrieve Wade, John Cornell and Norman Nelson from the frigid waters. Sadly, Wade had apparently decided to take a shortcut between the islands, instead of "wasting time" by driving the circuitous but safe route to the west of the currents. He paid for his haste with his life and the lives of five promising young men. The incident cast a deep pall over the small community, where everyone knew one another and many were related. And although it occurred more than seventy-five years ago, the town has not forgotten. Even in a place where danger and death often lurk a little closer to the surface, the senseless tragedy left a wound that has never fully healed.

Epilogue

DOOR COUNTY TODAY

All changes, even the most longed for, have their melancholy; for what we leave behind us is a part of ourselves; we must die to one life before we can enter another.

—*Anatole France, French writer*

Door County today is a bit of a paradox. Conservationists battle developers; visitors come for the peace and quiet but seek out attractions; and businesses fight to capture the tourist trade but only remain open for a few months out of the year. The county has slowly changed from its early days as a logging, fishing and mining community into a place that is primarily dependent on tourism. And that's the rub. Door County is not a place of stories-high roller coasters and high-tech amusement parks, but there are miniature golf courses and petting zoos. It does not feature fancy but artificial water parks—the water parks here are the shores of Green Bay and Lake Michigan. There are no casinos or trendy nightclubs, but there are plenty of fine restaurants, comfortable little taverns and a Shakespearean theater troupe. There are no outlet malls but instead hundreds of unique little shops, in which you'll be hard-pressed to find a "made in China" tag. There are no giant movie palaces encrusted in fake gilt but rather a very cool drive-in theater that dates to 1950 and still shows original cartoon commercials before each movie. No, Door County is not a place that lends itself well to flashy marketing campaigns, but most people who wind up on its shores find that they never want to leave.

In fact, a large percentage of the population is not native. Many of the homes belong to refugees from the cities who have come here to retire or start a new life. That's not to imply that the populace is limited to the

The *Edward L. Ryerson* at dock in Sturgeon Bay. It is one of only two remaining straight-deck bulk carriers still in use as part of the American fleet on the Great Lakes. *Photo by Peter Rimsa.*

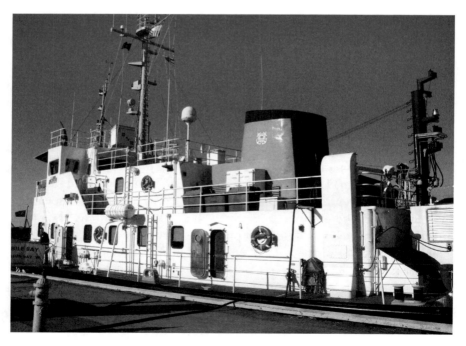

The shipping industry is still the lifeblood of Sturgeon Bay. *Photo by Peter Rimsa.*

AARP crowd; census figures show that the most-represented age group is fortysomethings, followed closely by adults thirty-five to thirty-nine and then teenagers. At coffee shops and cafés during the summer, it's common to see laptop computers strewn across tables as their owners telecommute to jobs in much less desirable locations. The year-round population hovers at about twenty-eight thousand but can easily swell to ten times that figure during the height of summer. Full-time residents are mostly employed in white-collar jobs, have at least some college education and have an income that mirrors the national average. Of course, these figures don't include the part-time residents, for whom homes in Door County are a second or even third residence. These can range from the relatively humble condominiums up to the multimillion-dollar compounds perched high on the shoreline bluffs.

During the "off-season," when most of the tourists depart and only permanent residents and hard-core devotees remain, the county slows to a gentle pace that hearkens back to its days as a true pioneer wilderness. The pioneers today, however, are more likely to be sculptors and painters than fishermen, more writers and poets than loggers. The birds, deer and other game face far more likelihood of being shot through a camera lens than through a gun barrel. Door County has a much higher per-capita concentration of fine artists, writers and musicians than perhaps any other place in the Midwest. But that's not to say that it has lost its original capital. The farmers continue to patiently coax crops out of the rocky soil, and fishermen still ply the waters in search of salmon or the perfect trout. Modern sailboats and kayaks skim the water, perhaps pausing for a moment to view the shallow remains of

The Sturgeon Bay Ship Canal Pierhead Light today. This image shows the catwalk suspended high above the water that allows Coast Guard access even in high wave conditions. *Photo by Peter Rimsa.*

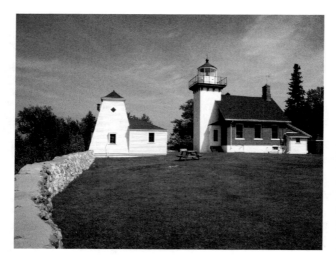

Sherwood Point Lighthouse is built with red brick, not the cream-colored Milwaukee brick used to build all of the other Door County lighthouses. *Photo by Peter Rimsa.*

a merchant ship that went down long ago during a treacherous storm. In the central lands, stands of beech and maple have been replaced in many areas by cherry and apples orchards, but the old forests are still abundant in spots, especially along the eastern shoreline. In fact, many residents divide the peninsula into two halves: the bustling "bay side" and the less-developed Lake Michigan coast, known as the "quiet side." It really doesn't matter where you choose to stay. The land narrows to just four miles wide at the tip, and only eighteen miles across at its widest point, the southern base south of Sturgeon Bay. It's a quick car ride from one side to the other—or a longer but arguably more pleasurable ride by bicycle or snowmobile.

As it moves into the twenty-first century, the county has to weigh its every move with caution and foresight, mixed with just the right amount of historical perspective. Too much development and it risks losing the rugged and peaceful persona that attracts its many visitors. Too little and it risks becoming an anachronism, a place left behind as time marches forward. So far, it has met that challenge quite well. Guests can sip cappuccino at a sidewalk café while checking e-mail via a nearby Wi-Fi connection and then put away the smartphone and watch the gulls and cormorants wheeling playfully in the impossibly blue sky. Most of the inns are equipped with satellite television and large flat-panel TVs, which often go unused because people would rather be out hiking the bluffs and listening to the lake breezes rattle the birch leaves. The people who linger here now are here by choice more than by necessity. They remain because they love the rich spirit of the land and all the natural wonders it offers up to those willing to stop for a moment and look and listen.

About the Author

G ayle Soucek is an author and freelance editor, with several books and numerous magazine articles to her credit, including *Marshall Field's: The Store that Helped Build Chicago* and *Chicago Calamities: Disaster in the Windy City*, both books published by The History Press. She once served as managing editor for the Chicago art and entertainment biweekly, *Nightmoves*.

She and her photographer husband divide their time between their home in a Chicago suburb and their second home in Baileys Harbor. As a child, Gayle first discovered her latent acrophobia on a climb up Eagle Tower during a family vacation. She's pretty sure that the claw marks she left on the railings remain to this day.

Visit us at
www.historypress.net